Shelley - 2004

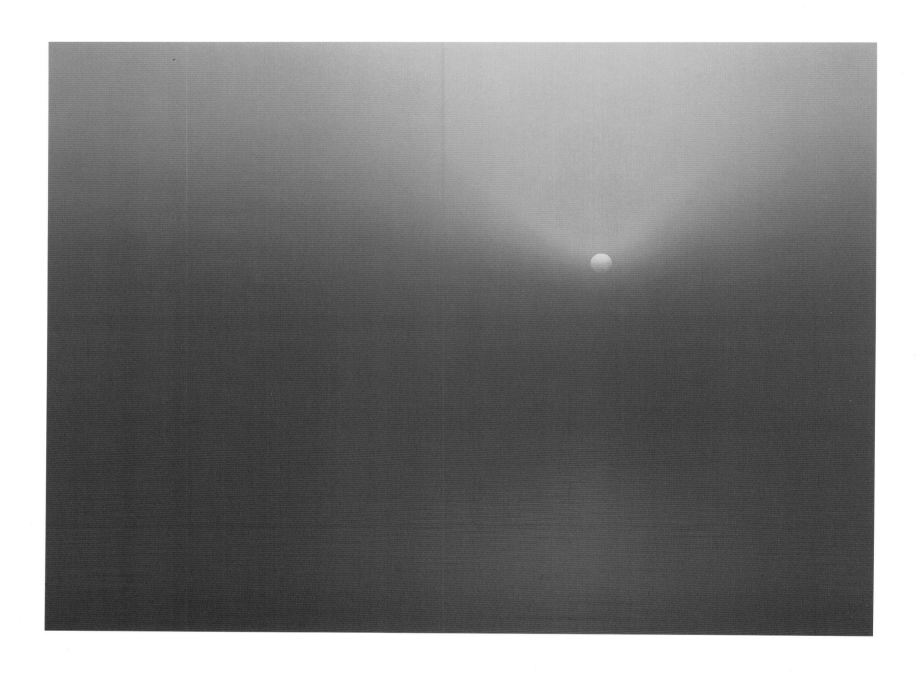

Sunrise throws orange-yellow light into heavy fog [CJ]

SUMMIT LAKE STATE PARK

UNEXPECTED INDIANA

A PORTFOLIO OF NATURAL LANDSCAPES

RON LEONETTI AND CHRISTOPHER JORDAN

Introduction by Mary McConnell,
Indiana State Director, The Nature Conservancy

AN IMPRINT OF
INDIANA UNIVERSITY PRESS
BLOOMINGTON AND INDIANAPOLIS

This book is a publication of

Quarry Books

an imprint of Indiana University Press
601 North Morton Street
Bloomington, IN 47404-3797 USA

http://iupress.indiana.edu

Telephone orders 800-842-6796
Fax orders 812-855-7931
Orders by e-mail iuporder@indiana.edu

The paper used in this publication meets the minimum require-
ments of American National Standard for Information Sciences—
Permanence of Paper for Printed Library Materials, ANSI Z39.48-
1984.

Printed in China

Library of Congress Cataloging-in-Publication Data

Leonetti, Ron, date
 Unexpected Indiana : a portfolio of natural landscapes /
Ron Leonetti and Christopher Jordan ; introduction by
Mary McConnell.
 p. cm.
 ISBN 0-253-34485-9 (alk. paper)
 1. Indiana—Pictorial works. 2. Landscape—Indiana—
Pictorial works. 3. Natural areas—Indiana—Pictorial works.
4. Parks—Indiana—Pictorial works. 5. Natural history—
Indiana—Pictorial works. 6. Landscape photography—
Indiana. I. Jordan, Christopher, date II. Title.
 F527.L46 2004
 977.2—dc22
 2004004594

1 2 3 4 5 09 08 07 06 05 04

In memory of my father.
His passion for the outdoors was surpassed only
by his love for and commitment to family.
You are with me always.

RL

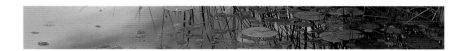

In memory of my mother, who left us too soon
and has missed so many things.
I miss you every day,
and I will always be proud to call you Mom.

CJ

CONTENTS

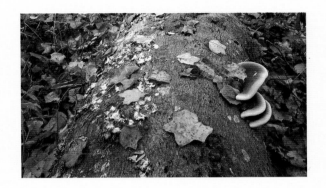

Portfolio 1

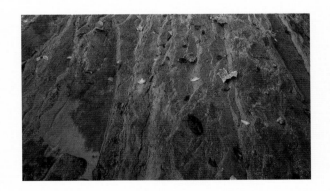

Acknowledgments

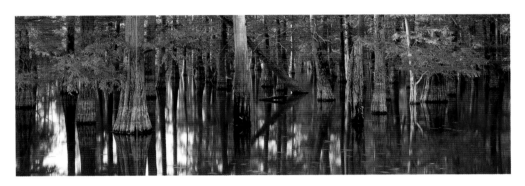

WE would like to thank the many people who contributed their time and energy to this project and to making this book possible. Our profound appreciation to the Indiana Chapter of The Nature Conservancy for their many contributions. Mary McConnell wrote a wonderful introduction on short notice, and in the midst of an already hectic schedule. Chip Sutton and Matt Klage helped us in coordination with The Nature Conservancy as a whole, Fiona Solkowski produced a beautiful map for us, and Ellen Jacquart and John Shuey provided expert assistance in species identification. In addition, without our mutual participation in the "Preserving Place" exhibit sponsored by The Nature Conservancy and the Indianapolis Museum of Art, we would not have started this collaboration in the first place.

Lloyd Brooks went above and beyond in his willingness to assist us in sequencing and coordinating the photographs. We are sincerely grateful to him for his expert and generous help in providing a harmonious flow to the images.

Thanks to Indiana University Press for sharing our passion for this book and agreeing to participate in making it a reality. Michael Lundell, Emmy Ezzell, Bryan Gambrel, Mary Beth Haas, and Robert Sloan all provided invaluable guidance and expertise in their various specialties. Special thanks to Sharon Sklar for her beautiful book design, which presents this portfolio so well.

Finally, our gratitude to all the organizations and employees who maintain, manage, protect, and preserve the natural landscapes still remaining in Indiana. The crucial work you do has provided us with the locations and palette to practice our art.

RL & CJ

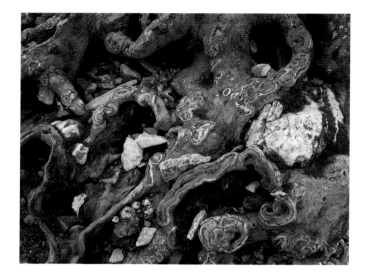

I wish to thank those who have helped me along the way. To Christopher Jordan, there have been far too many coincidences for this to be anything but destiny. Thanks for being a good partner and such a good friend. To my brother Mark, who has carried my bag many miles without complaint and always mustered up a smile at the end of the day. Your enthusiasm for my success speaks volumes of your character. Special thanks go to my father-in-law, Jack Carlson. He has been not only a good companion on the trail but a great friend and someone whose qualities I can only aspire to emulate. To my sons, Jake and Tony, your love and understanding has been a powerful source of inspiration for me. You two mean the world to me. Finally, to my wife, Tammy, whose unconditional love and support has refocused me in many more ways than I can describe here. None of this would have been possible without you. Thank you for being who you are and sharing your life with me.

RL

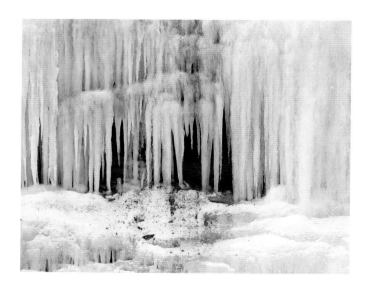

I am deeply grateful to the many people who helped make this book possible. Obviously a collaborative project cannot be completed without a willing and capable partner, and Ron Leonetti fits both those adjectives wonderfully well. Ron, your photography is a joy to behold, and I continually benefit from close interaction with you. You are a lot of fun to work with, whether shooting in the field, poring over possible images to include in the book, or just shooting the breeze while waiting for the, well, breeze to die down. Thanks for making this project a great experience from start to finish (whenever that is!) and for proving that honesty, companionship, and doing the right thing can be combined in such a productive way. Thanks also to the lovely Tammy, who is always patient and supportive when I interrupt her evenings at home with phone calls to ask when I can interrupt her time with Ron to go out photographing.

My family is unique and very precious. Dad and Judy, Heather and Neil, and Randy and Holly (as well as Jaxon, Michael, and

Abby) are the family members (besides Carrie-Ann) that I turn to most often for support and help of various kinds, and they are always there for me. Thanks for being so GOOD at being a family—you make me proud to be part of the group. I would also like to thank Mom for her unwavering confidence. I know if you were still here you would look me straight in the eye with a big smile and say, "I knew you could do it." You would have loved seeing this. I also want to express my genuine appreciation to my extended family—Jordan, Johnson, Fisher, and McPhee—for your encouragement. I love you all.

Thanks to Patrick Matthiessen for encouraging me to start photographing in the first place. You probably don't know what a mentor you were to me when I was starting out, or how deeply I appreciate the unselfish way you and Jenn have supported my work. Thanks to Bill and Chris Dean for unrelenting faith and confidence, and for always telling me "It's all good" even when I'm not really convinced. Particular thanks to Diane Ellis for her steady and unwavering support in some difficult times. The friendships of the Dean, Ellis, and Matthiessen families are very dear to me, regardless of distance or time. I am very grateful to Lloyd Brooks, Jeff Schafer, and Kristin Todd for their contributions to this project, both direct and indirect.

Over the five years I have worked on this book, I have received a steady flow of encouragement, companionship, and support from many people. They are too numerous

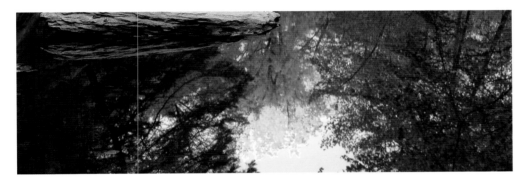

to list individually, and to attempt a listing would only ensure that an important name would be omitted. However, each person is an important part of my life, and I owe each of you a debt of gratitude.

Finally, I would not be who I am without Carrie-Ann in my life. I am deeply honored to have the privilege of sharing my life with you, and your consistent belief in me is exhilarating and humbling. Thank you for loving me so fully and for being my safest place. I choose you.

CJ

Artists' Comments

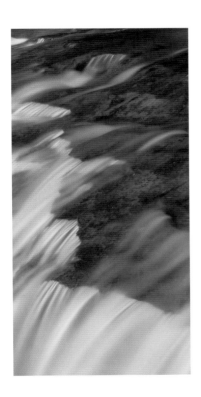

My affinity for the outdoors was shaped while I was growing up in Michigan. As a young boy I explored the streams, lakes, and hardwood forests that dominated the southern part of the state. After completing high school, I went away to college in the Upper Peninsula at Northern Michigan University, which is located on the southern shore of Lake Superior. It was there that I came to understand just how important it would be for me to have access to and commune with the natural world. For the next twenty-some years, I would spend as much time as I could traversing the great expanses of unspoiled landscape in the Great Lakes State, mostly with a camera in hand.

In 1994 I made a job-related move to Indianapolis. I still remember that first drive down I-69. Just south of the border, Indiana looked a lot like Michigan, with lakes and forest in view from the road. However, the farther south I drove, the more the forest was replaced by fields of corn and the land took on a look of relative flatness. Being promoted and moving to a new metropolitan area was exciting, but it saddened me to think of how far away the places that had given me such pleasure and sanctuary were now. At the time of my arrival, I really did not know much about Indiana. There was the Indianapolis 500, which we would watch on television every May; and from my drive down, the state appeared to be as agriculturally oriented as a Great Plains State. What I would come to learn is that Indiana is a place filled with friendly people, great historical and cultural significance, and a somewhat low-profiled yet dynamic diversity of ecosystems.

I have come to find Indiana to be a place where northern and southern bio-communities intertwine. A place where a small stretch of land along the southern shore of Lake Michigan is considered to be as biologically significant to the Midwest as the Grand

Canyon is to the Southwest. This is also a state where in the southwest corner bald cypress trees flourish, making you feel as though you are in the bayous of the Deep South. What lies in between is a myriad of mixed forest, chiseled lime and sandstone canyons, prairies and glaciated lakes and bogs. There are mighty rivers that move great volumes of dark water within them. There are small creeks that run clear as they cut through the bedrock of time, exposing fossilized remains of life from millions of years past. Breathtaking waterfalls of all sizes dot the southern half of the state. This is a state where you can find massive sand dunes, deep underground caverns, and natural arches. This, I would learn, is Indiana.

I found Indiana to be so beautiful and full of wonder that I was compelled to pick up my large format camera to record and share with others what I have come to revel in. Over the last four years, I have logged some thirty thousand miles searching out and experiencing the special places that make up Unexpected Indiana. In that effort I have come to know Indiana for what it was, is, and can be. There is so much natural diversity, and yet so little of it left.

Photographing unspoiled natural landscapes is rewarding and also very challenging. Many of the protected places and areas bend and yield to our access and use. The spray painting and carving on trees and canyon walls are a sad reflection and visual commentary on who we are and how we manage these precious places. We must accept the challenge to take a more proactive role of stewardship in order to ensure that those who follow us will also be able to experience this natural heritage as it is intended to be and as it should remain.

I hope that these images will surprise you and give you pleasure all at once. More important, I truly hope that they will inspire you—inspire those who do not know Indiana as well as they thought to get out and get intimate with its natural beauty. Renowned naturalist John Muir once wrote that most people are living on the world rather than in it. Though we can no longer truly live in these set-aside and protected places, you can take the time to experience them. The end result will shape what you think about Indiana and hopefully how you treat the natural splendor that exists here.

RL

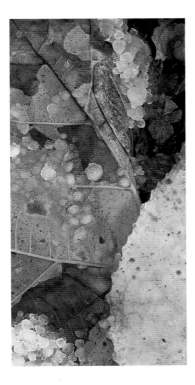

When I tell someone that I am a photographer with a particular interest in fine art landscapes, they generally express interest in where and how I work. Telling them that I pursue this passion in Indiana and surrounding states produces anything from genuine interest to polite confusion to downright skepticism. I have been told many times that there must not be much to photograph if I'm only going to take a day trip from Indianapolis. This is unfortunate, because the diversity of the Indiana landscape is really quite amazing. Any geographic area that contains rivers, streams, waterfalls, lakes, wetlands, swamps, forest of all types, prairies, savannahs, dunes, canyons, cliffs, and an extensive variety of plants and animals must have something of interest for the attentive photographer.

I photograph because I respond emotionally to the beauty of the natural world. My passion is the exploration of natural beauty and hidden gems in the eastern half of the United States, with an emphasis on the Great Lakes region. The landscape here is sometimes referred to as "subtle" or "quiet." This can be an acknowledgment of the type of beauty found here, or it can be a polite way of saying "boring." I definitely choose the former interpretation, and I constantly strive to find images and scenes that express that belief. In fact, I would gently suggest that those leaning toward the latter interpretation should look again with a little more care and attention.

I believe that nature is worthy of exploration regardless of scale or distance. I believe that a foggy sunrise in the wetlands at Pokagon State Park is every bit as beautiful as a foggy sunrise at the Snake River overlook in the Tetons. I believe that a streambed in southern Indiana and a streambed in southern California are equally complex and interesting. A close-up of a leaf frozen in ice is just as gorgeous as a panoramic view of Brown County, and each of these scenes stands on its own as an example of the wonder of the natural world. One of my greatest joys is finding some surprising detail or unexpected landscape that reveals its own personal beauty based on time of day, time of year, and weather conditions.

I hope that this passion will be contagious in some small way, and that readers of this book will find that their eyes are attuned a little more to the joys of exploring the natural landscape just outside their own door. The next time you visit a park or hike a trail, try looking a little more closely and see if you can't find your own Unexpected Indiana.

CJ

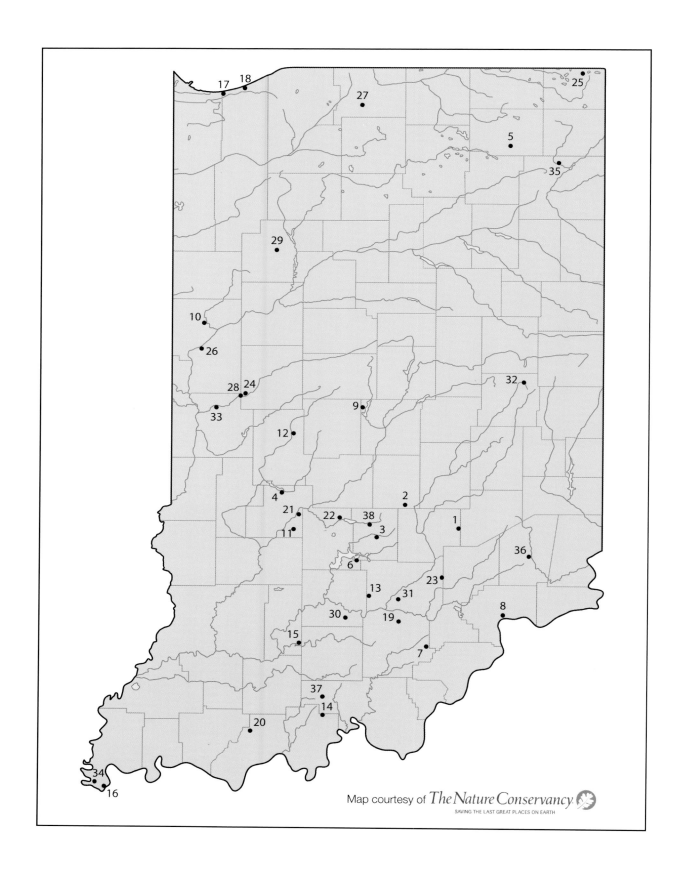

17 18
25

27

5

35

29

10

26

28 24
33

32

9

12

4

21
22 38
11 3
1

36

6

23
13 31
8

30 19

15

7

37
14

20

34
16

Map courtesy of *The Nature Conservancy*
SAVING THE LAST GREAT PLACES ON EARTH

List of Locations

Introduction

Mary McConnell

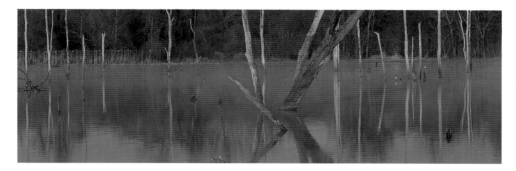

Indiana is blessed (or cursed, depending on your perspective) with roads. Lots of roads. Lots and lots of roads. Roads that take us to just about anyplace that we want to go and to some places that we don't. Roads that take us to the city or to the country. Roads that take us to a shopping mall or to a ball game. Roads that take us from the shores of Lake Michigan to the banks of the Ohio River. And some roads that take us to the most unexpectedly beautiful places in the state. These are my favorite roads.

Journey, for example, to the far southwestern corner of the state, to the "big toe" of Indiana, to the place where all roads abruptly end. Here, at the confluence of the Ohio and Wabash rivers, you will see stands of bald cypress sloughs. No, you are not in Mississippi or Louisiana; you are still in Indiana. Venture to the end of the boardwalk at Twin Swamps Nature Preserve in Posey County some early summer's day and witness these remarkable cypress sloughs, which are at their extreme northern range along the Wabash River.

As you travel toward the shores of Lake Michigan in the far northwestern corner of Indiana, you will encounter gigantic sand dunes colliding with coastal forests, white sands literally burying the trees as they march inland in a silent battle for domination. You are not at the Outer Banks of North Carolina; you are at the Indiana Dunes National Lakeshore. The National Lakeshore is one of the tiniest properties owned and managed by the National Park Service (about 15,000 acres), but don't be misled by its small size. This property ranks seventh in the country for its diversity of plant species, just behind

such behemoths as Great Smoky Mountains National Park and Grand Canyon National Park, both encompassing millions of acres.

The image of tall prairie grasses swaying in a cool summer breeze is perhaps not the first thing that comes to mind when you think of Indiana. Just over a century ago, it might have been. Historical accounts document grasses growing so tall in Indiana that a man on horseback would be swallowed up. The state's beautiful rich expanses of prairie are all but gone today, but fragments still cling to existence, offering us a unique glimpse of our past. Follow the railroad along State Road 43 and US Route 421 from Lafayette to Monon and you are following virgin Indiana prairie. Retrace your route every few weeks and you will see a different set of prairie flowers in bloom each time. As the grasses grow taller throughout the growing season, flowers of sequentially loftier heights reach maturity and bloom, reaching their crescendo in late fall, with purple asters and bright yellow prairie dock reaching heights of ten feet or taller.

The rolling hills of Brown County and its neighboring counties are familiar to almost all Hoosiers. Weekend drives in the country offer spectacular views, especially in the fall, along State Road 46 from Columbus to Nashville to Bloomington, or, even better, along State Road 135 from Bean Blossom to Story. Next time get out the gazetteer and allow the adventurer in you to be enticed onto roads that are even more obscure, such as Greasy Creek Road or Bob's Road. Travel into the Hoosier National Forest and discover Browning Mountain, pick up a free orienteering map at the Story Inn and hike into a wilderness, or just drive on roads that wind endlessly, bringing you unexpected vistas at every turn.

The winding roads of southern Indiana twist around some of the most spectacular scenery in the state. The Knobstone Escarpment is Indiana's most prominent topographical landmark, rising more than three hundred feet in some areas as it snakes northward from the Ohio River to southwest of Indianapolis. Narrow, flat-topped ridges, steep slopes, and deep V-shaped valleys provide rugged terrain and many scenic overlooks. But you have to leave the interstate to find them. A drive along Dogtrack Road in Washington County will lead you to Henderson Park, a preserve harboring two of the northernmost limestone glades in the country, four hundred acres of hardwood forest, and three large aquatic caves.

Bogs, fens, and marshes; lake after lake after lake; golden tamaracks, carnivorous pitcher plants, and sundews. This has all the makings of an Everglades documentary, but a drive up to northeast Indiana would yield the same elements. Practically every county road will take you past a lake or a wetland of some sort. Glaciers that retreated out of Indiana more than ten thousand years ago left behind this soggy patchwork of wetlands as

their distinctive calling card. Outdoor enthusiasts from every corner of the state and beyond are drawn to Indiana's lake country, and it never disappoints.

Sunlight filtering through a majestic forest. Forest floors blanketed with a thick mat of spring bluebells. The splendor of brilliant fall foliage. Icy cold streams, gurgling and babbling, tumbling and dancing through a snowy winter valley. These sights are all here in Indiana and all here for you to discover.

Indiana is a remarkable state because we have so many hidden natural treasures. We are not just flat cornfields and interstate highways. We are a rich assemblage of natural diversity and natural beauty that is ours to find, enjoy, and protect. Wander off the interstates and onto the state highways or, better yet, the county roads and discover the wealth and beauty of a state that has so much to offer to everyone.

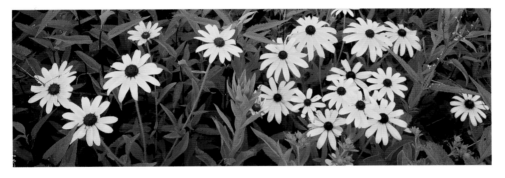

Christopher Jordan and Ron Leonetti have done a remarkable job of depicting the amazing natural beauty of Indiana. Their stunningly beautiful photographs capture the true essence of the natural world of the state. Take a close look at their images and allow yourself to be drawn into the beauty that is found in every corner of Indiana. Expect the unexpected. Delight in the truth.

Portfolio

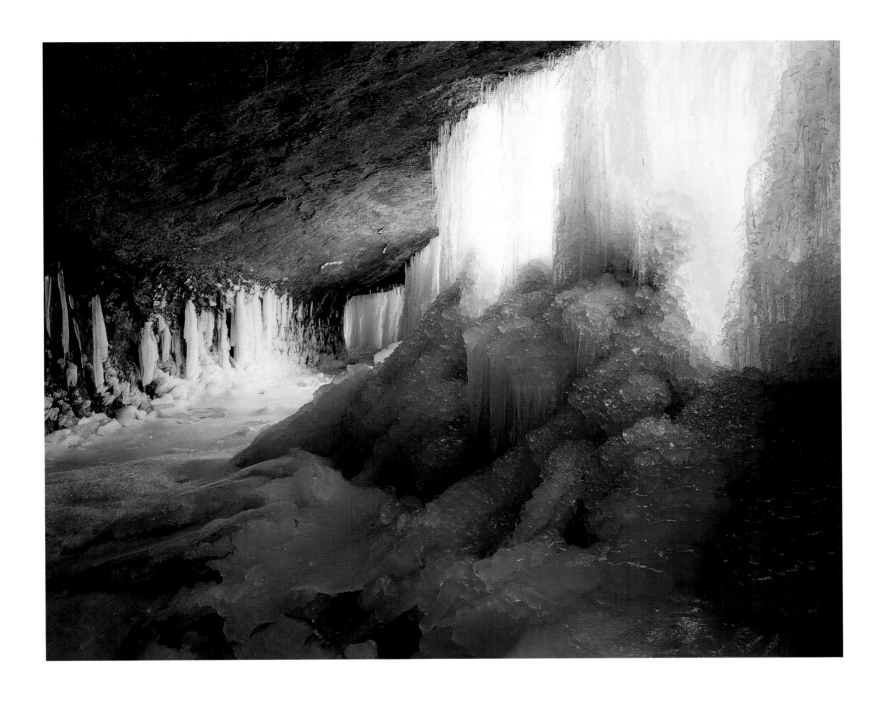

During the coldest of winters, the upper falls is transformed into a spectacle of ice [RL]

CATARACT FALLS STATE RECREATION AREA

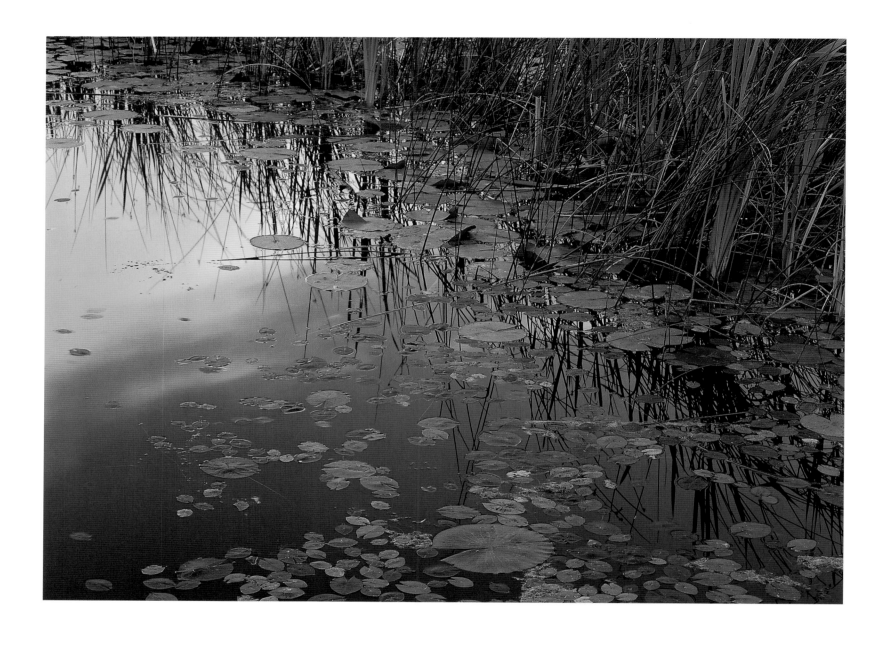

Lily pads, cattails, and reflections in Lake Lonidaw [CJ]

POKAGON STATE PARK

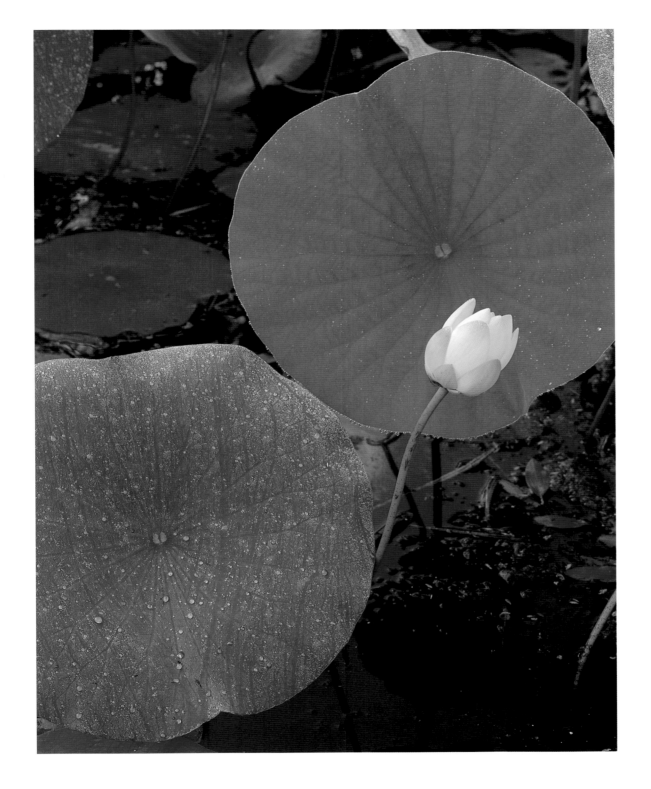

American lotus, Yellowwood Lake [CJ]

YELLOWWOOD STATE FOREST

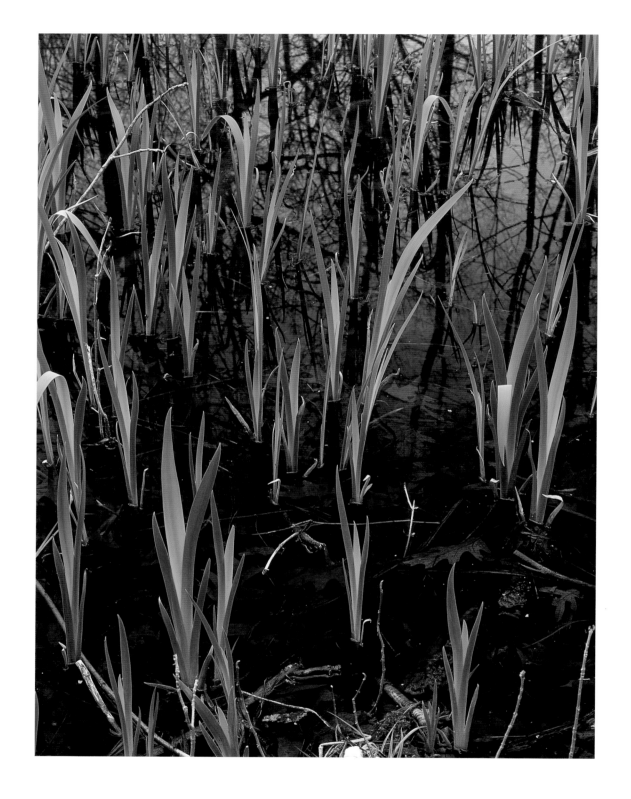

A small patch of cattails forms a random pattern on the forest floor [CJ]

POTATO CREEK STATE PARK

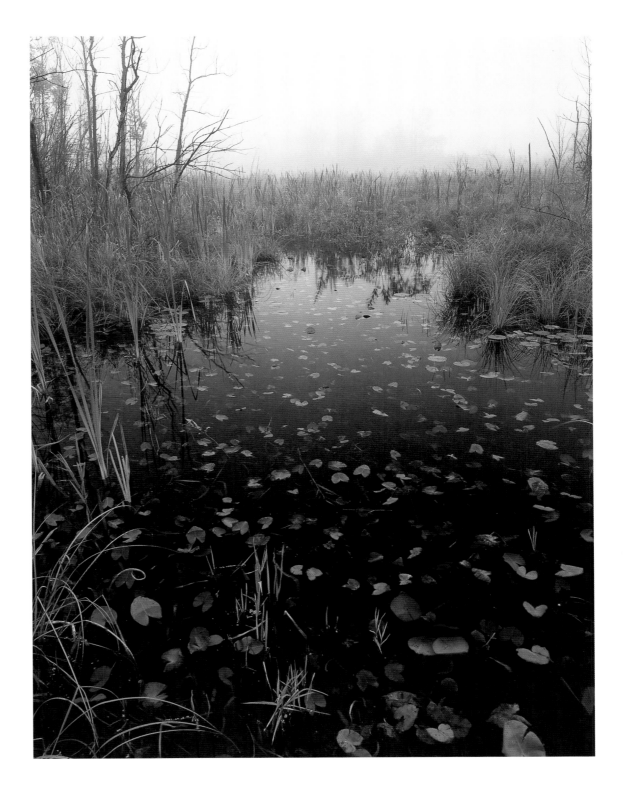

Wetlands plants dot the channel leading into Lake Lonidaw [CJ]

POKAGON STATE PARK

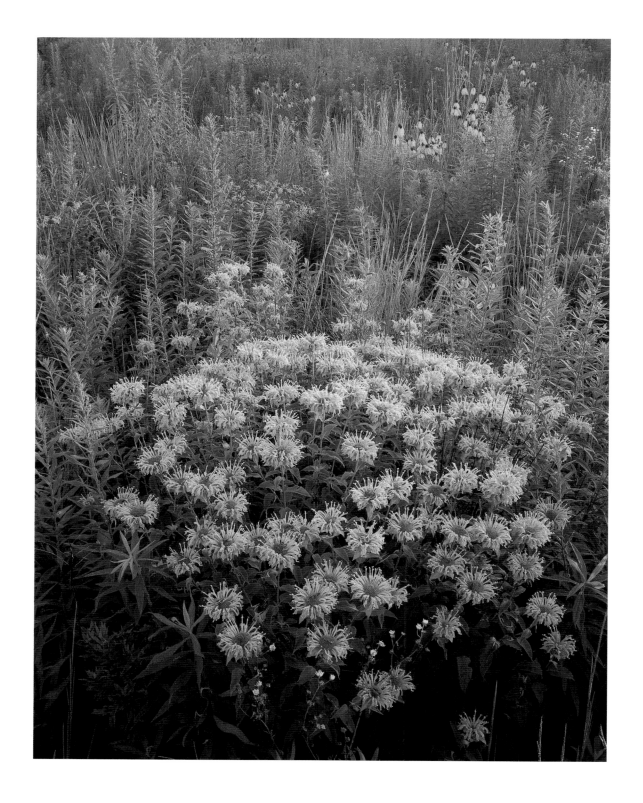

A bouquet of wild bergamot stands out among prairie coneflowers [RL]

BENTON COUNTY

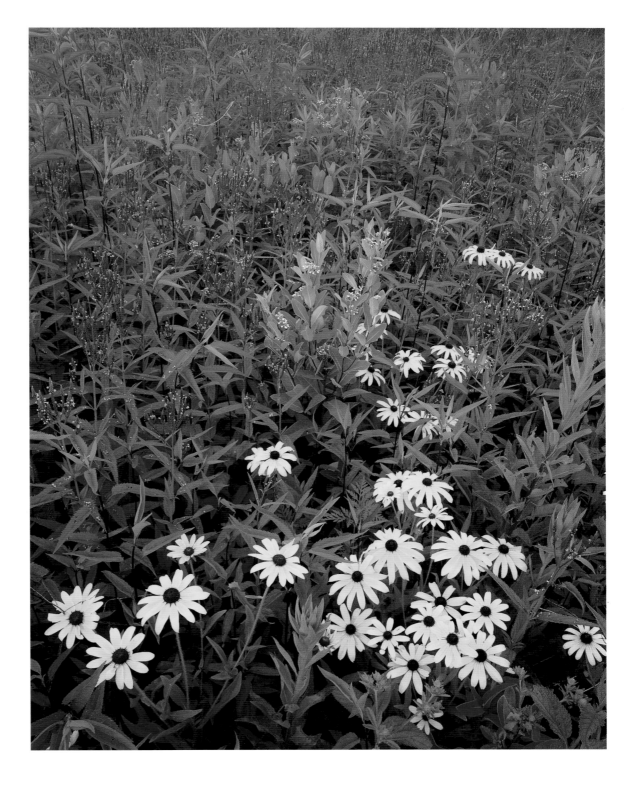

*Black-eyed Susan mingle with blue
vervain southeast of Spencer* [RL]

Owen County

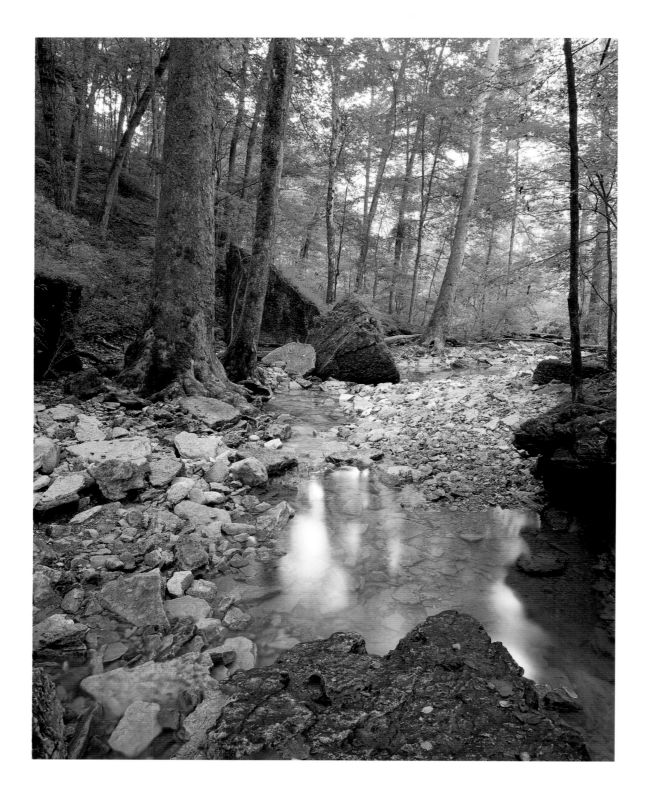

Little Clifty Creek below
Little Clifty Falls [CJ]

CLIFTY FALLS STATE PARK

Marsh marigold and skunk cabbage carpet the forest floor [CJ]

POTATO CREEK STATE PARK

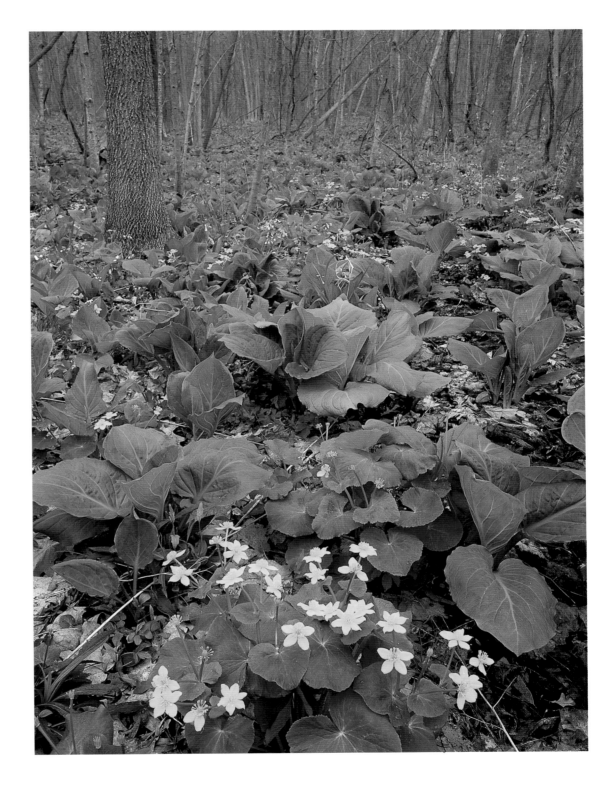

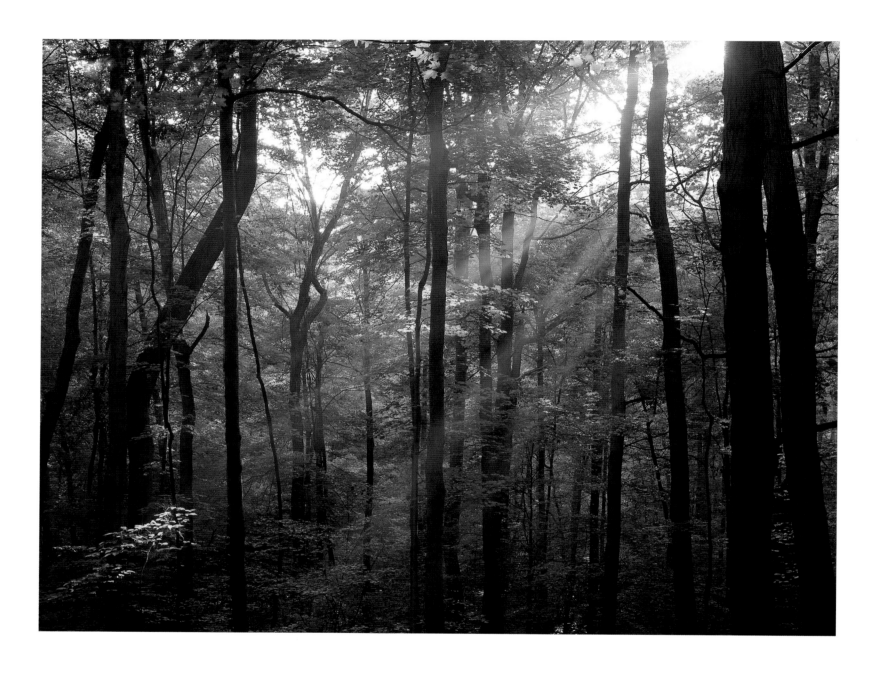

Sunrise pierces through light mist [CJ]

GREEN'S BLUFF NATURE PRESERVE

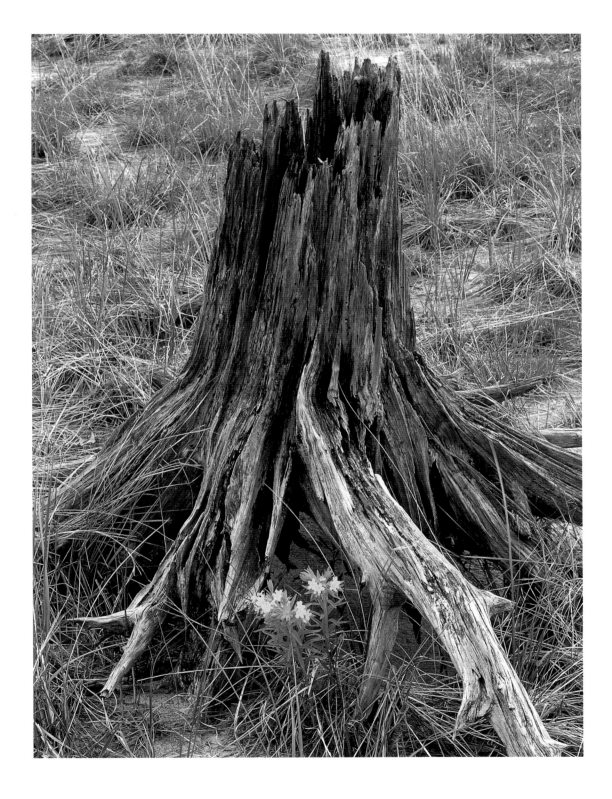

A hairy puccoon shelters next to a large stump [CJ]

INDIANA DUNES STATE PARK

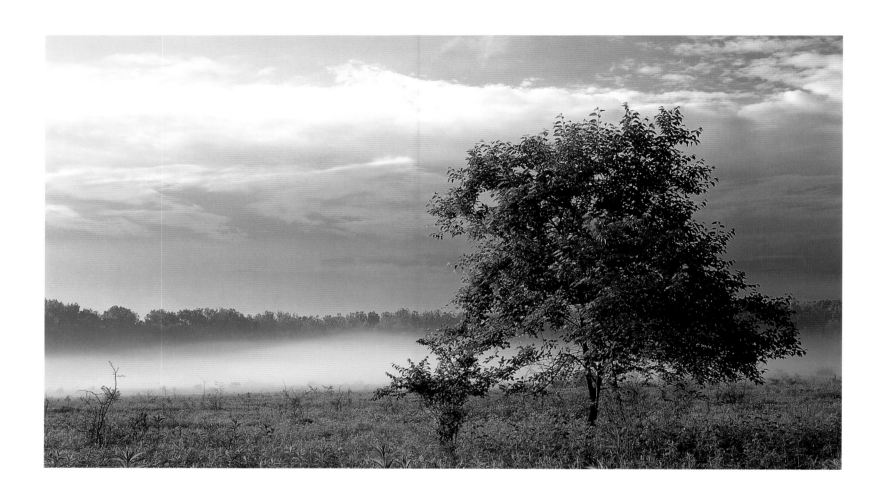

Morning sun sidelights a small tree in a meadow [CJ]

ATTERBURY FISH & WILDLIFE AREA

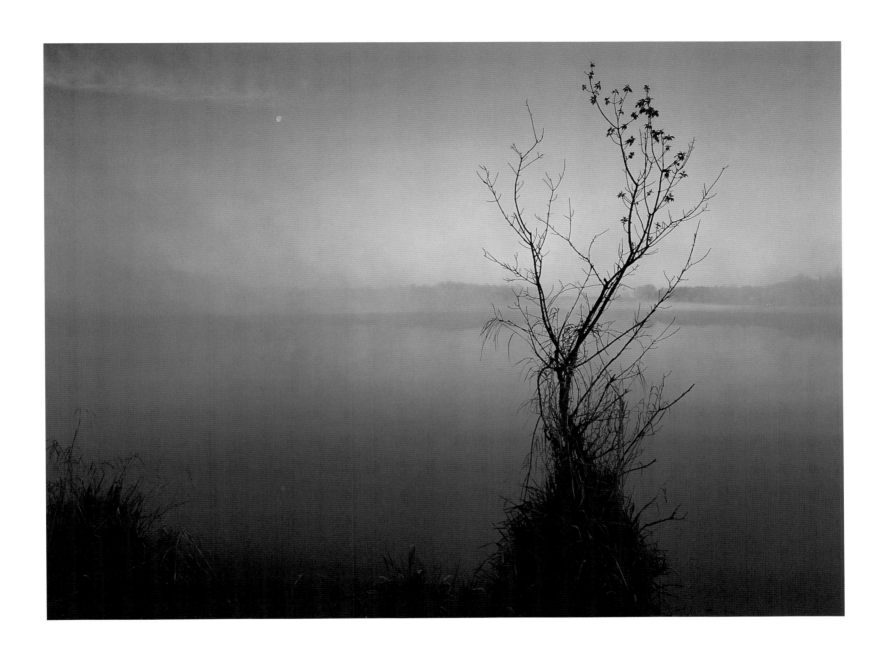

Small tree silhouetted against the fog on Worster Lake [CJ]

POTATO CREEK STATE PARK

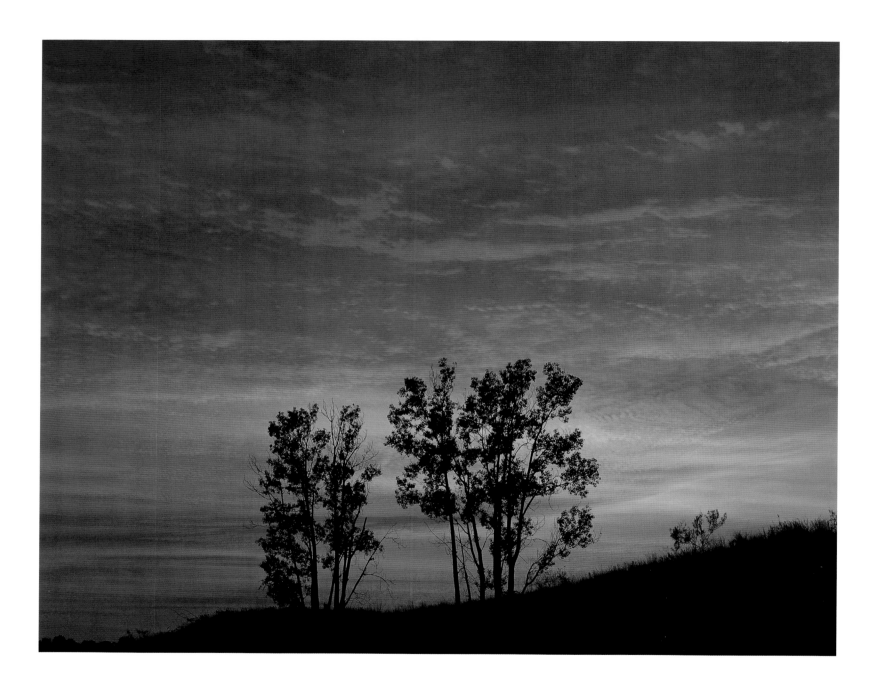

Sunset over the dunes at West Beach [CJ]

INDIANA DUNES NATIONAL LAKESHORE

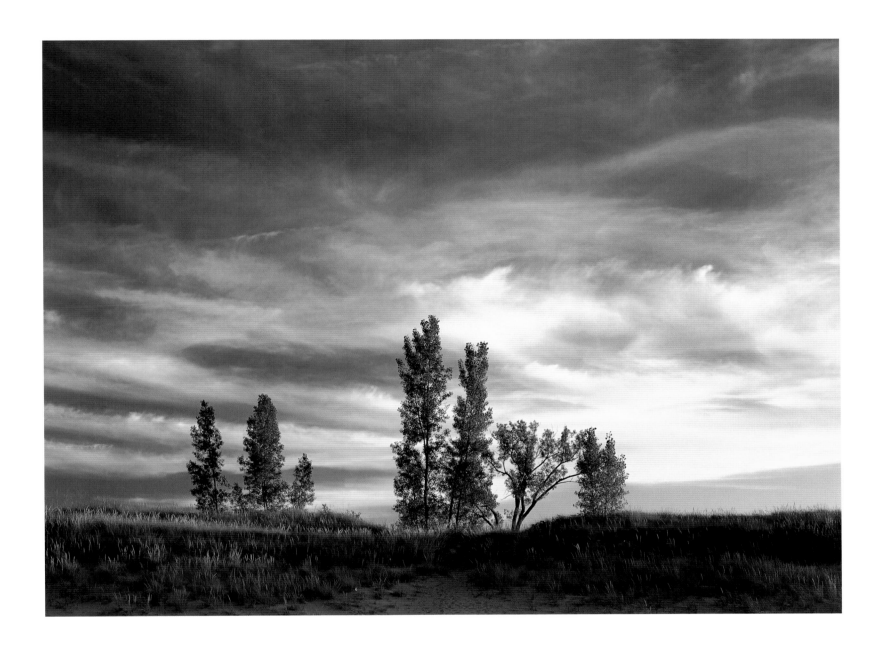

Dunes, grasses, and cottonwood trees at West Beach [CJ]

INDIANA DUNES NATIONAL LAKESHORE

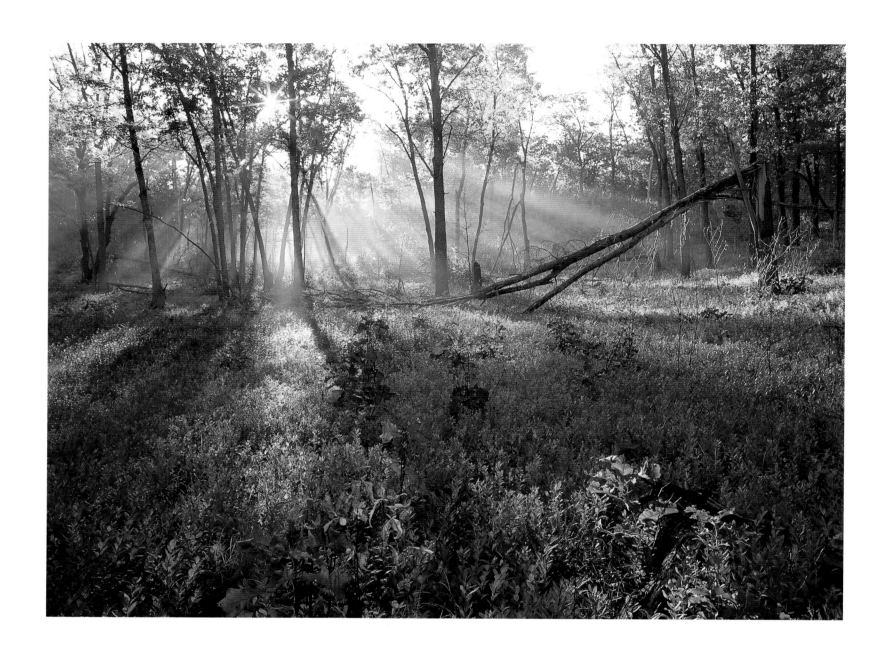

Autumn morning light floods an oak savannah [CJ]

INDIANA DUNES STATE PARK

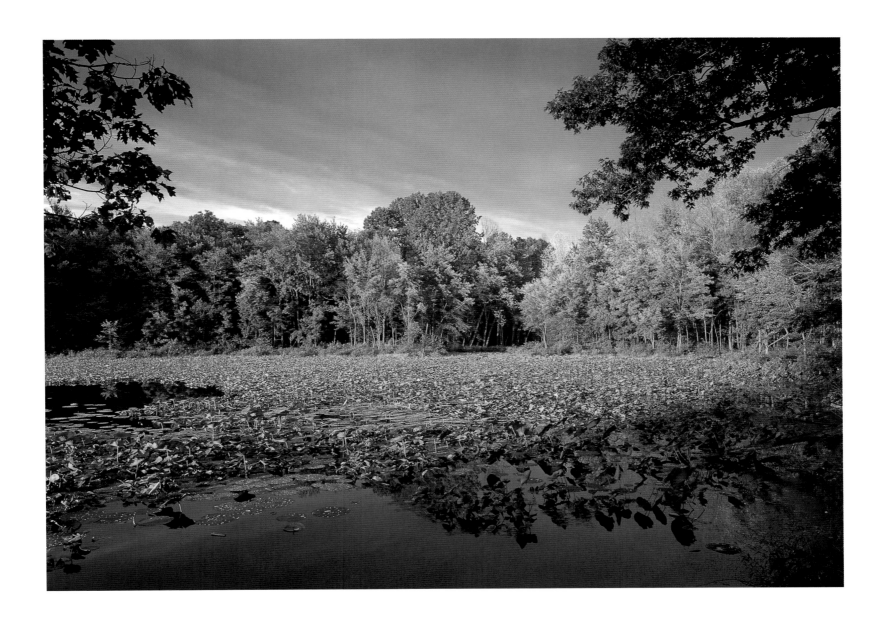

Warm evening sun lights the trees and American lotus in Lake Lincoln [CJ]

LINCOLN STATE PARK

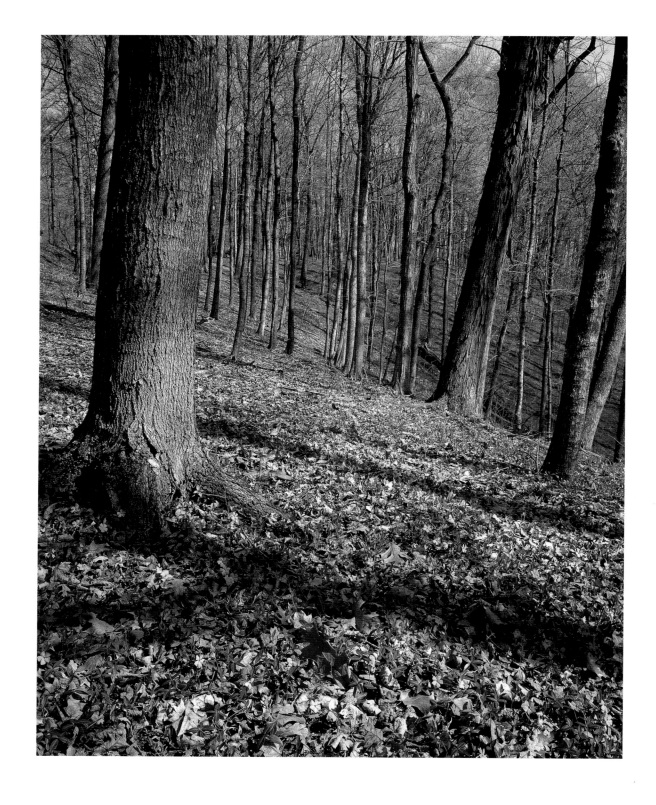

Periwinkle blooming among
hardwood giants [RL]

SPRING MILL STATE PARK

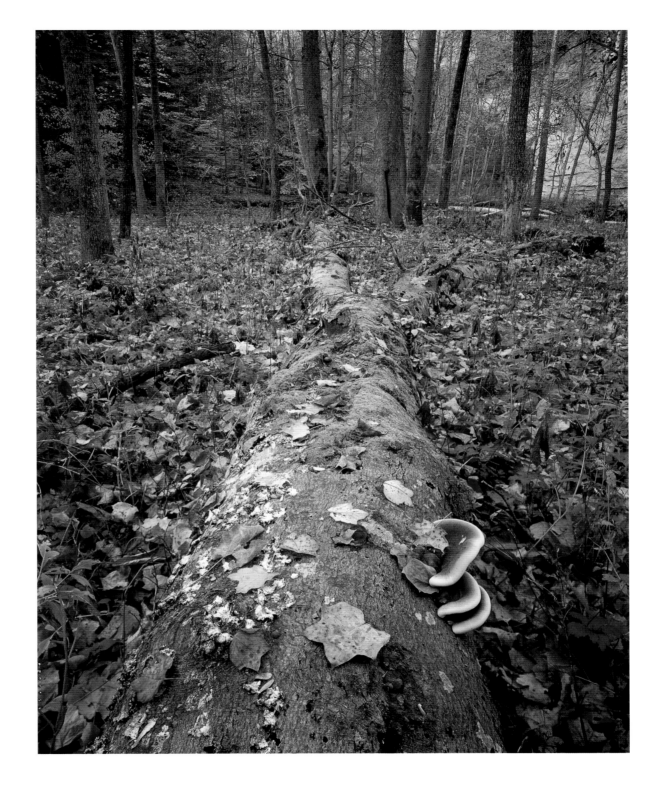

A fallen beech tree brings
nourishment to the forest floor [RL]

PINE HILLS NATURE PRESERVE

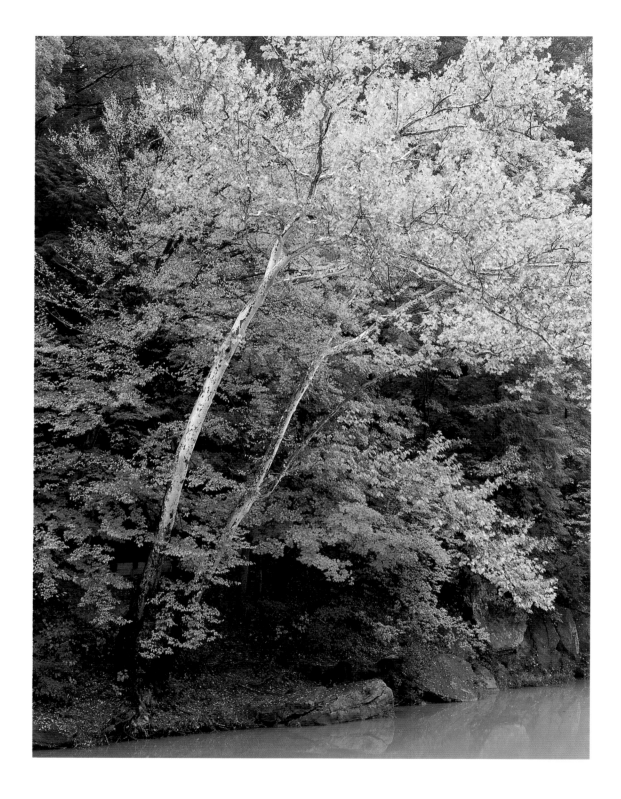

A sycamore tree along Sugar Creek [CJ]

Turkey Run State Park

Afternoon sunlight illuminates
a hardwood forest [RL]

POKAGON STATE PARK

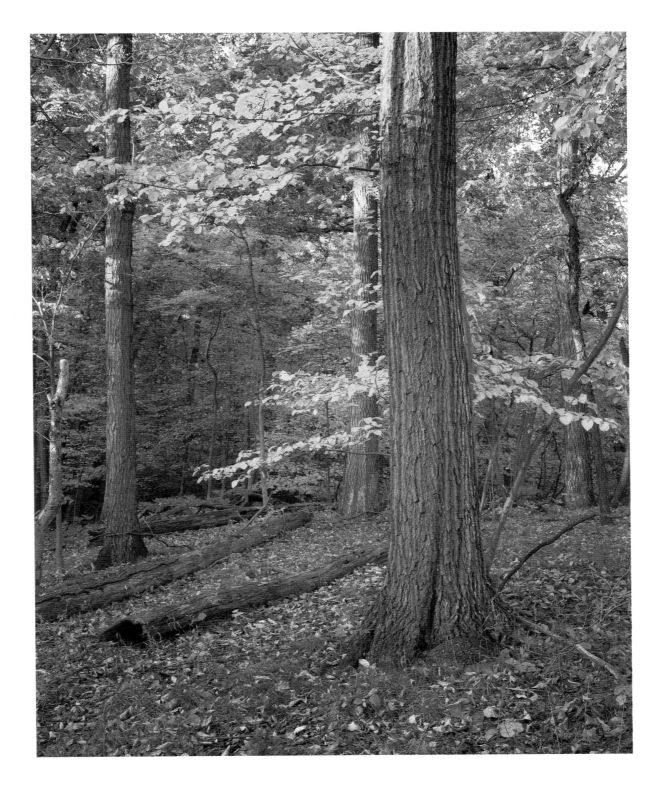

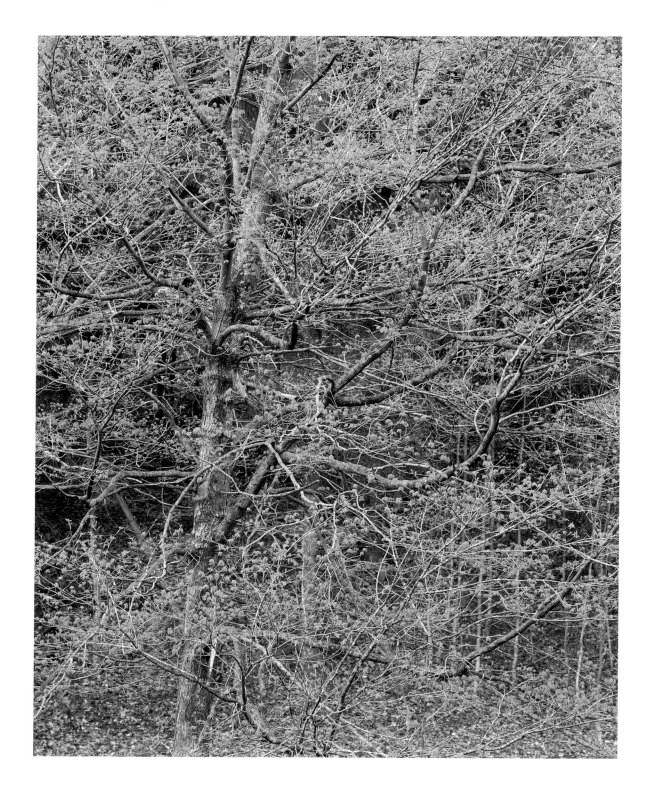

Spring explodes among the trees [RL]

BROWN COUNTY STATE PARK

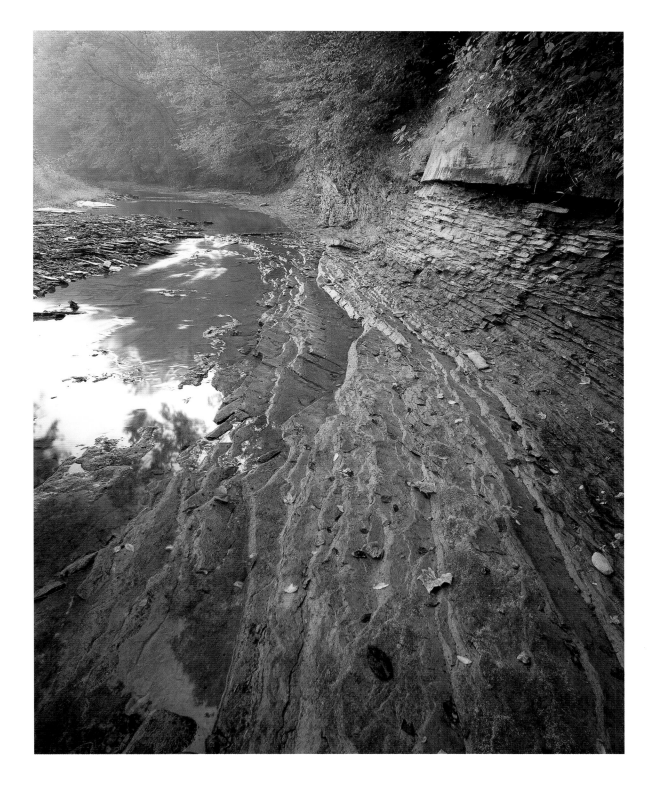

Guthrie Creek cuts its way through
ancient bedrock [RL]

HEMLOCK BLUFF NATURE PRESERVE

25

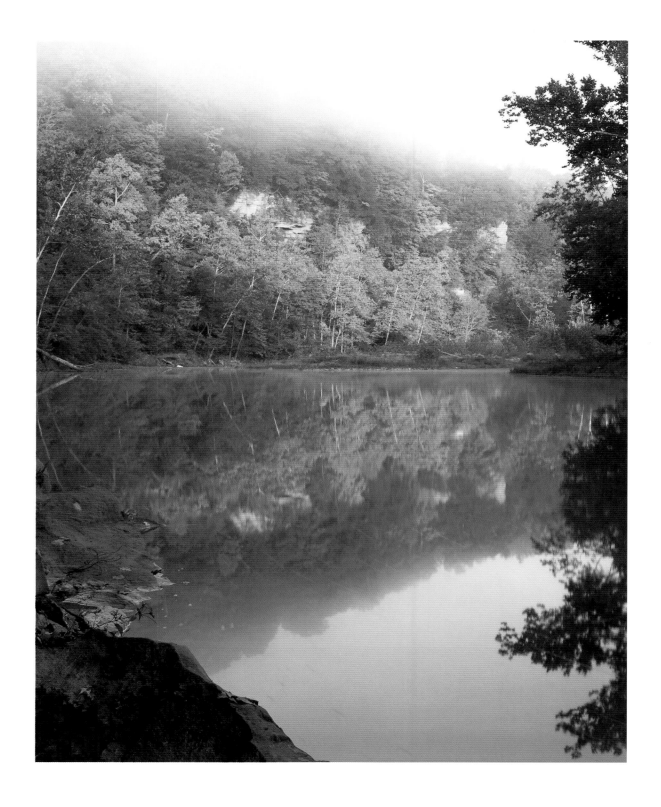

Fog and light dance on forested cliffs [RL]

SHADES STATE PARK

The namesake for Indiana's first dedicated nature preserve [RL]

PINE HILLS NATURE PRESERVE

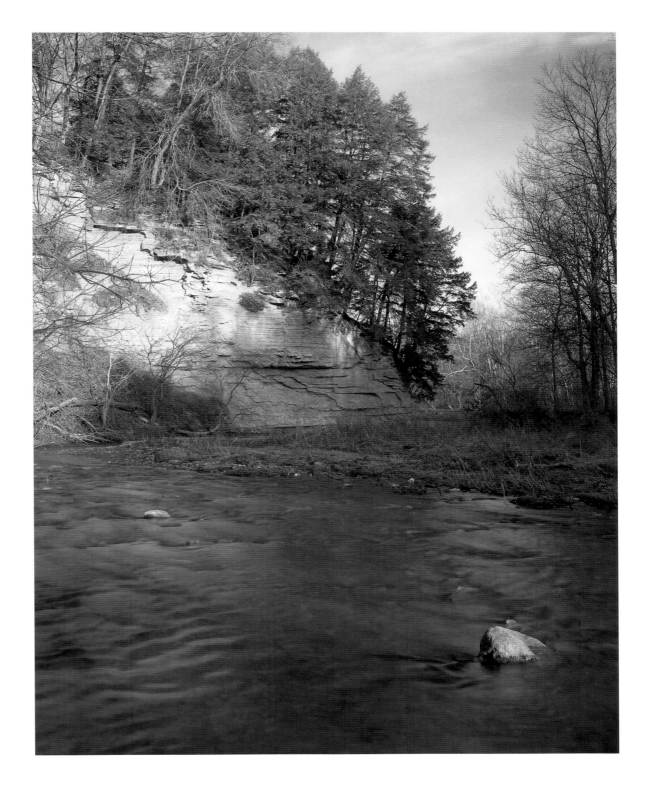

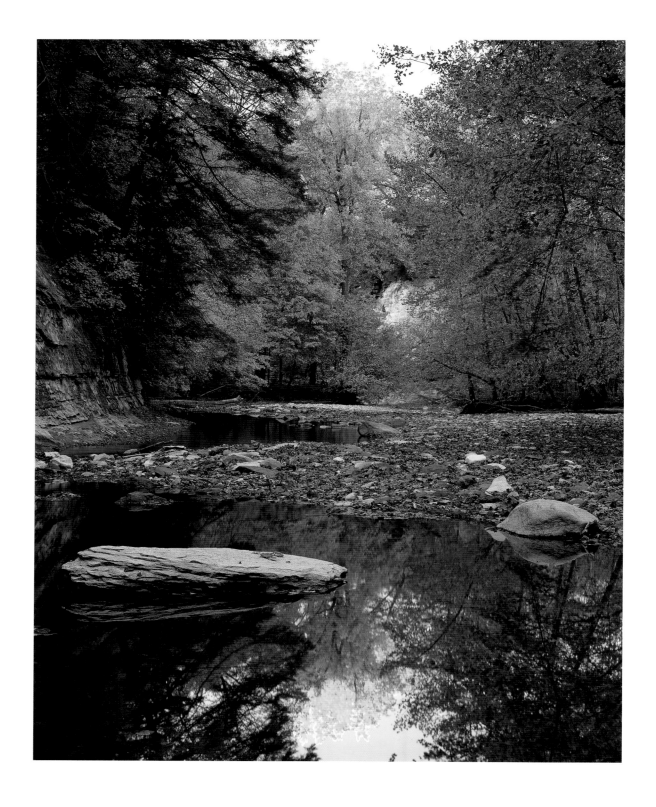

*A glow of autumn colors along
Indian Creek* [CJ]

PINE HILLS NATURE PRESERVE

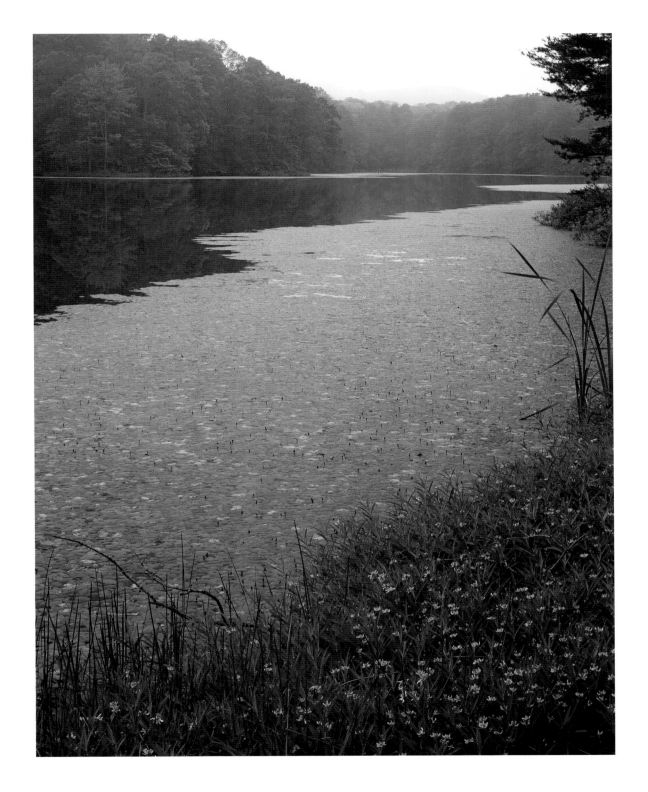

A summer morning view across
Schlamm Lake [CJ]

CLARK STATE FOREST

29

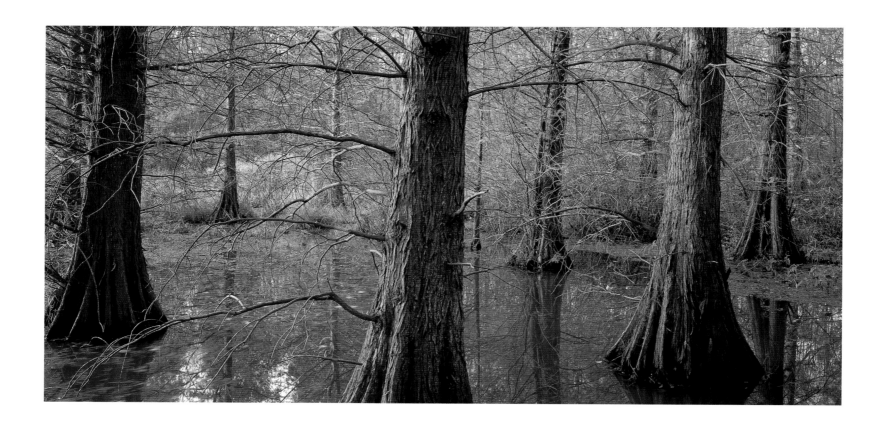

A small stand of bald cypress trees along the edge of Starve Hollow Lake [CJ]

STARVE HOLLOW STATE RECREATION AREA

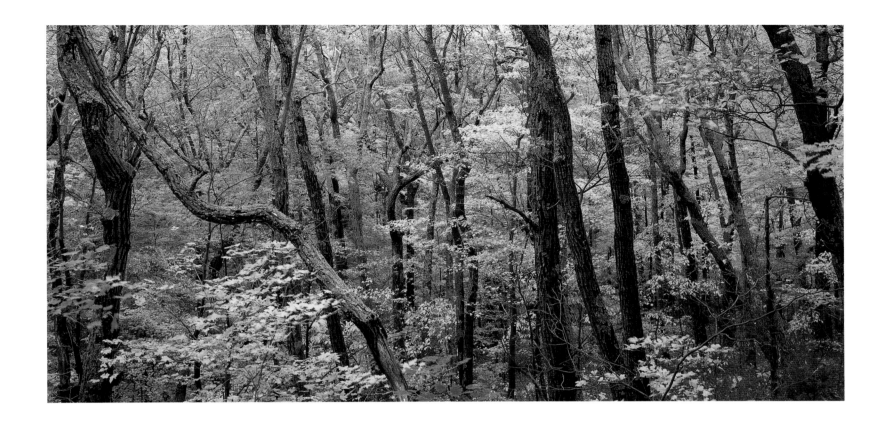

Autumn forest abstract [CJ]

JACKSON-WASHINGTON STATE FOREST

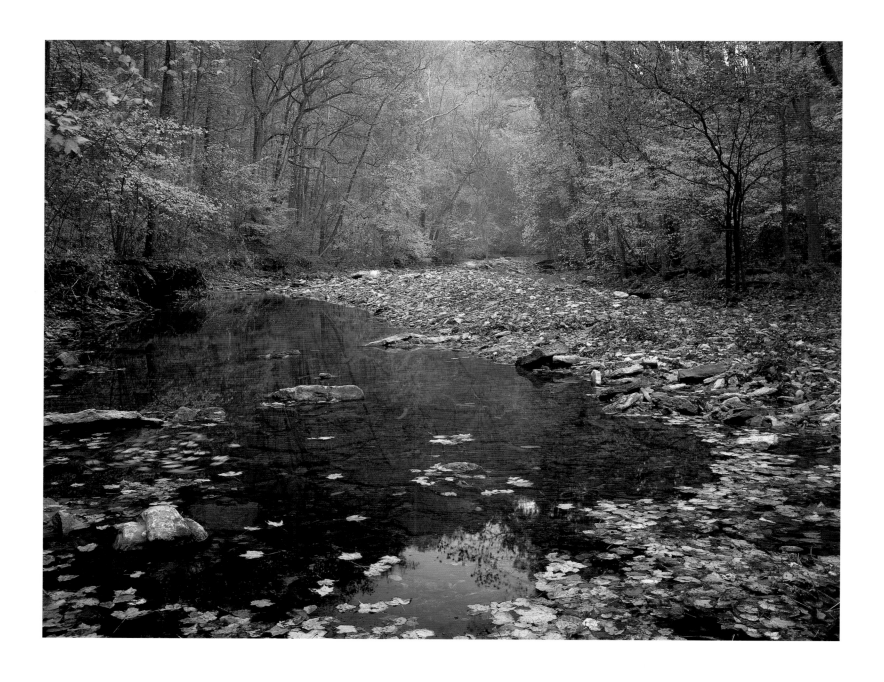

Yellow leaves and fall colors along Clifty Creek [CJ]

CLIFTY FALLS STATE PARK

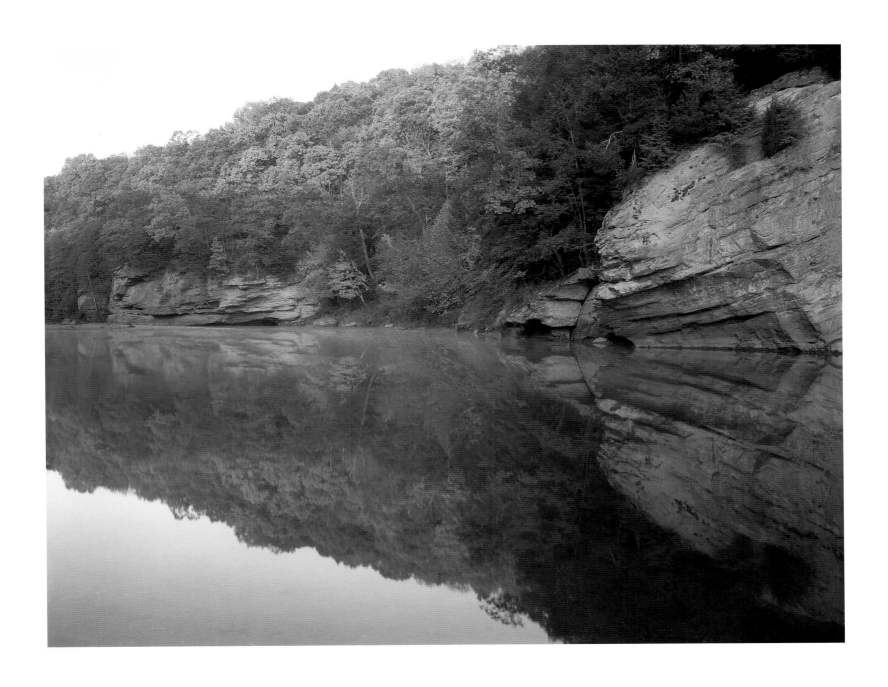

Reflections of fall along Sugar Creek [RL]

TURKEY RUN STATE PARK

One of the many seasonal waterfalls that can be found around the Hemlock Cliffs [RL]

HEMLOCK CLIFFS RECREATION AREA

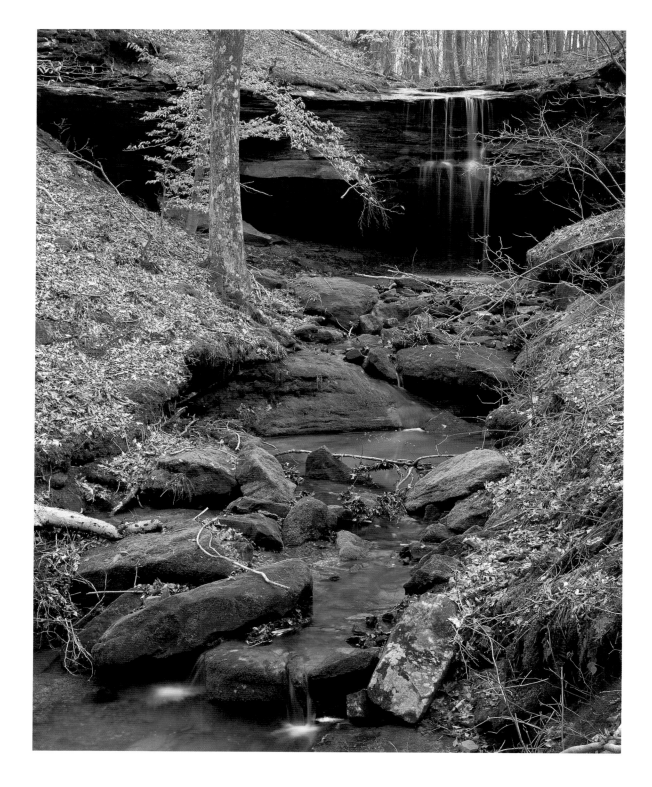

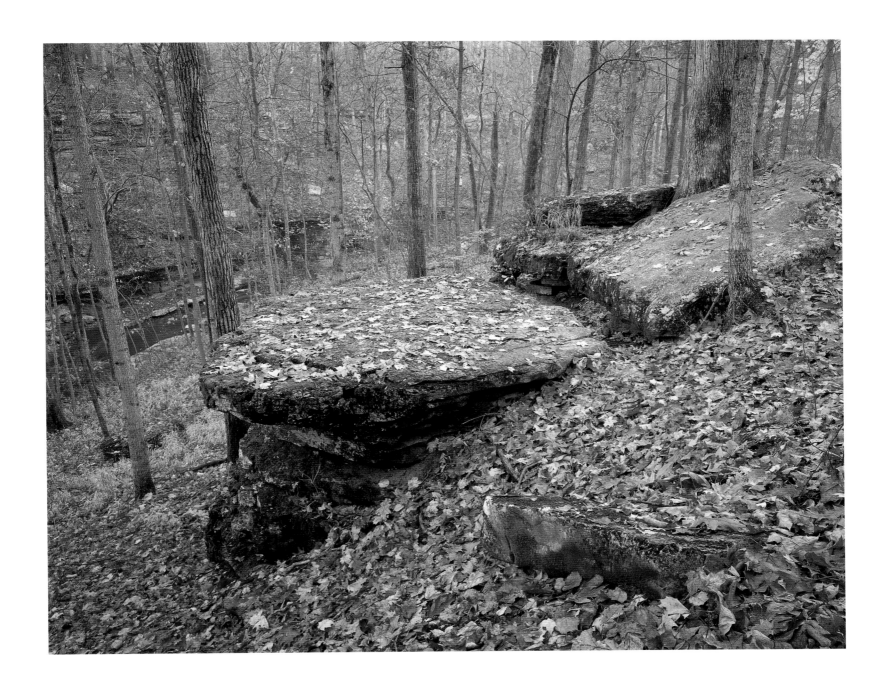

Giant rock outcroppings above McCormick's Creek in late fall [RL]

McCormick's Creek State Park

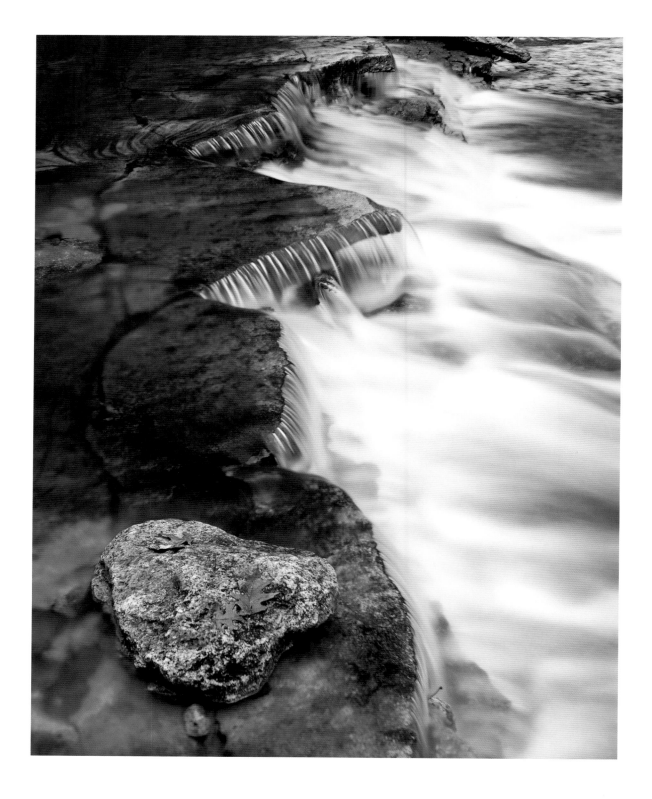

A break in the Ordovician rock bed of Big Clifty Creek creates an ethereal falls [RL]

CLIFTY FALLS STATE PARK

Fallen leaves dress up
McCormick's Creek Falls [RL]

MᴄCᴏʀᴍɪᴄᴋ's Cʀᴇᴇᴋ Sᴛᴀᴛᴇ Pᴀʀᴋ

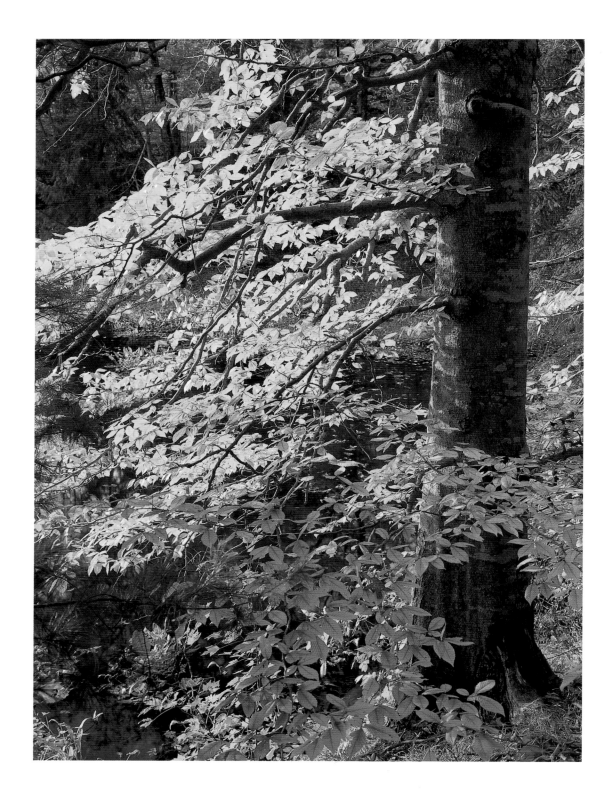

A beech tree in fall color [CJ]

Morgan-Monroe State Forest

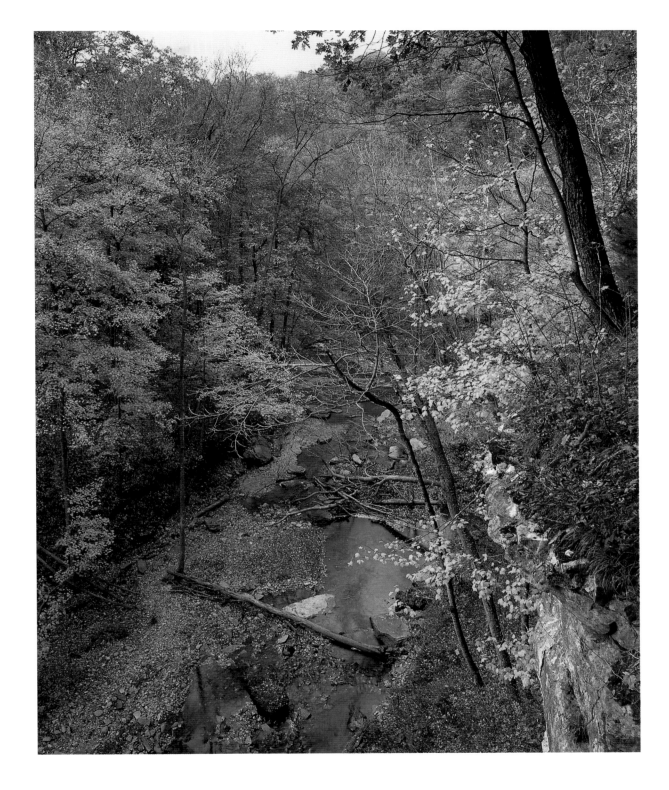

*Looking down into McCormick's
Creek canyon* [CJ]

McCormick's Creek State Park

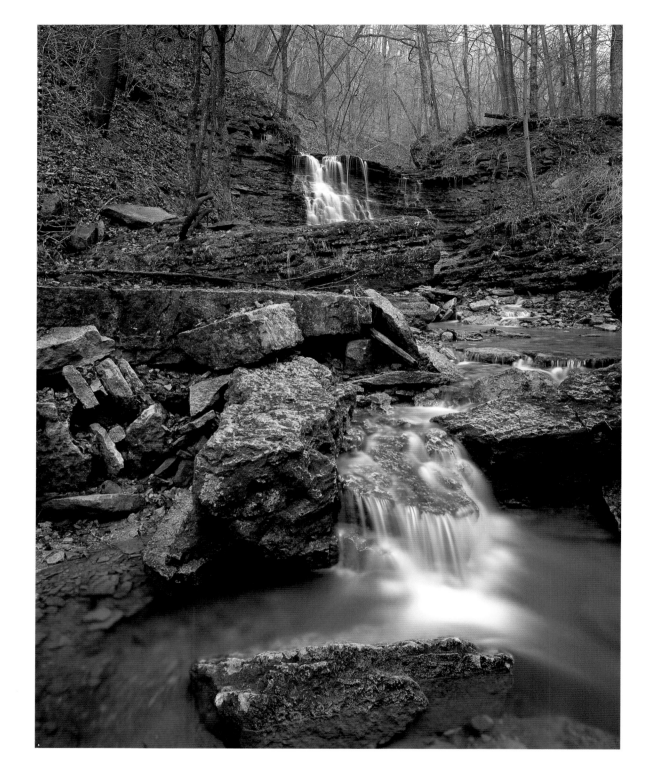

Hoffman Branch of Clifty Creek cascades over a small waterfall [CJ]

CLIFTY FALLS STATE PARK

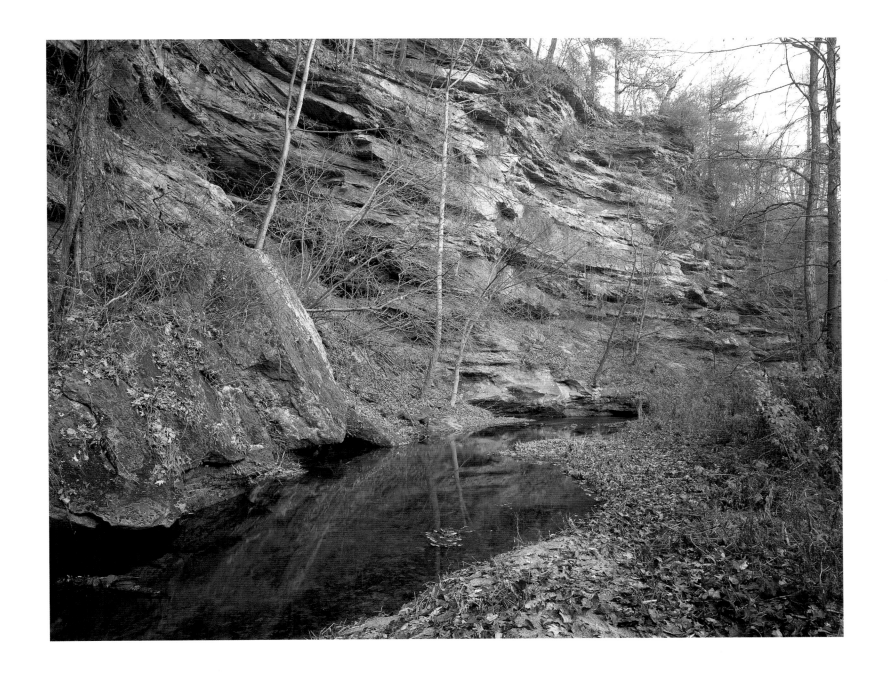

Sandstone cliffs tower over Bear Creek [RL]

PORTLAND ARCH NATURE PRESERVE

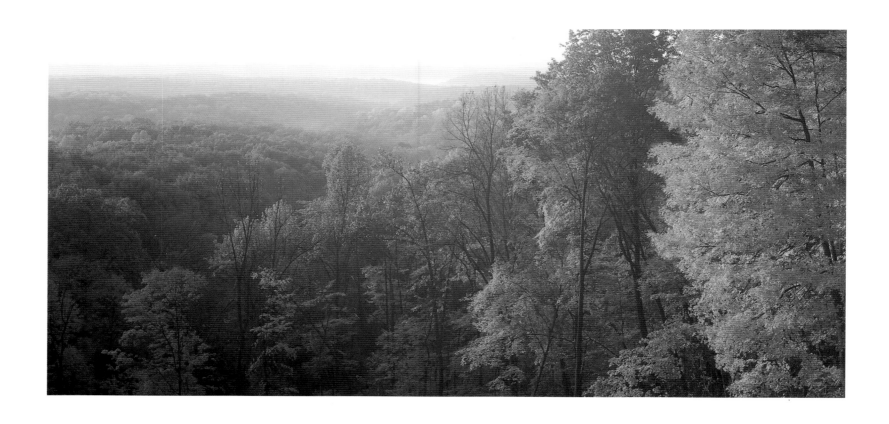

An autumn sunrise exposes fall's colorful spectacle in south-central Indiana [RL]

BROWN COUNTY STATE PARK

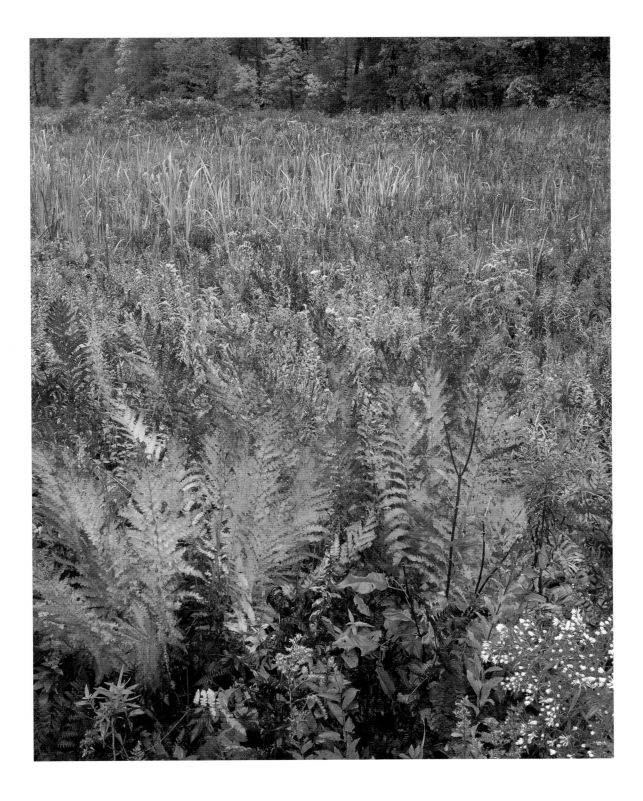

Fall along the Calumet Trail [RL]

INDIANA DUNES NATIONAL
LAKESHORE

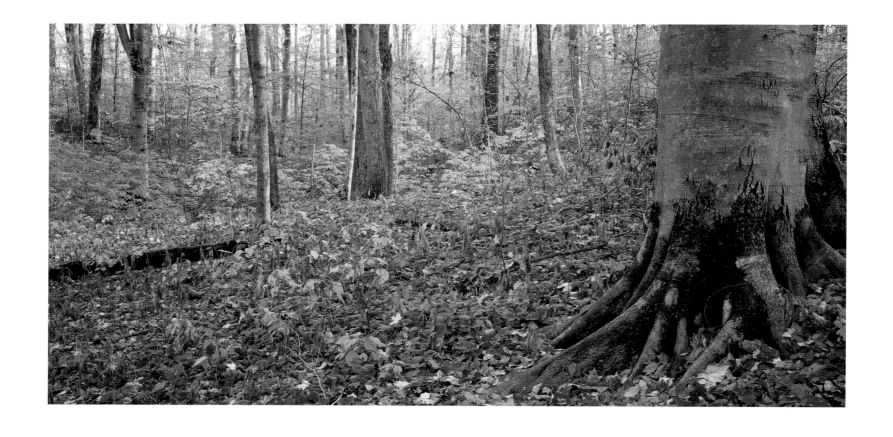

Pristine forest can be viewed from the trails in Wolf Cave Nature Preserve [RL]

McCormick's Creek State Park

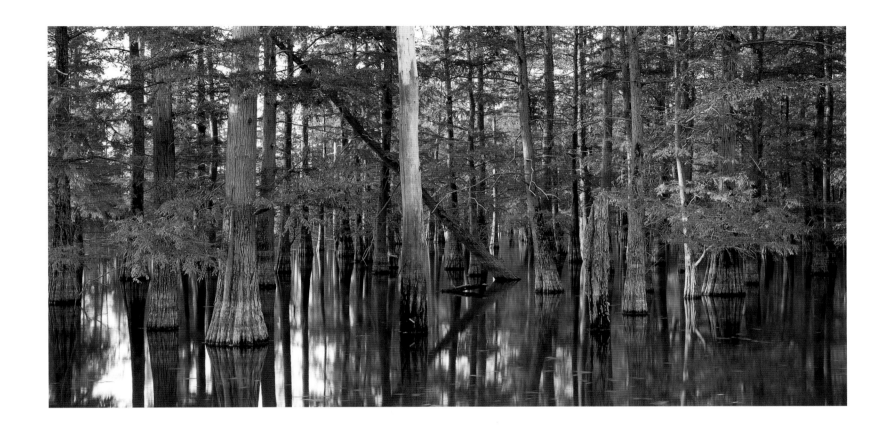

Morning light intensifies the fall color in a stand of bald cypress [RL]

Hovey Lake Fish & Wildlife Area

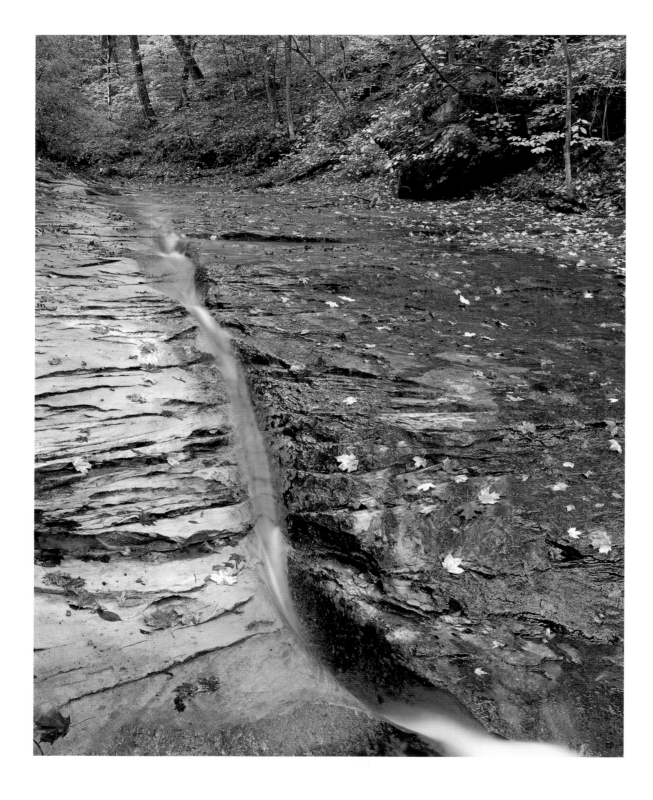

A feeder creek funnels its way down and into Fall Creek [RL]

FALL CREEK GORGE
NATURE PRESERVE

A foggy autumn morning along
Fall Creek [RL]

FALL CREEK GORGE
NATURE PRESERVE

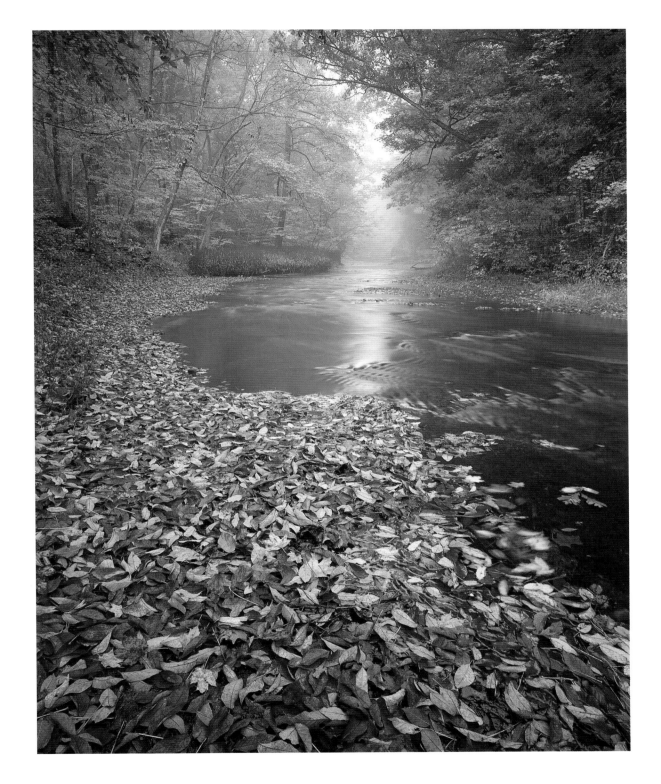

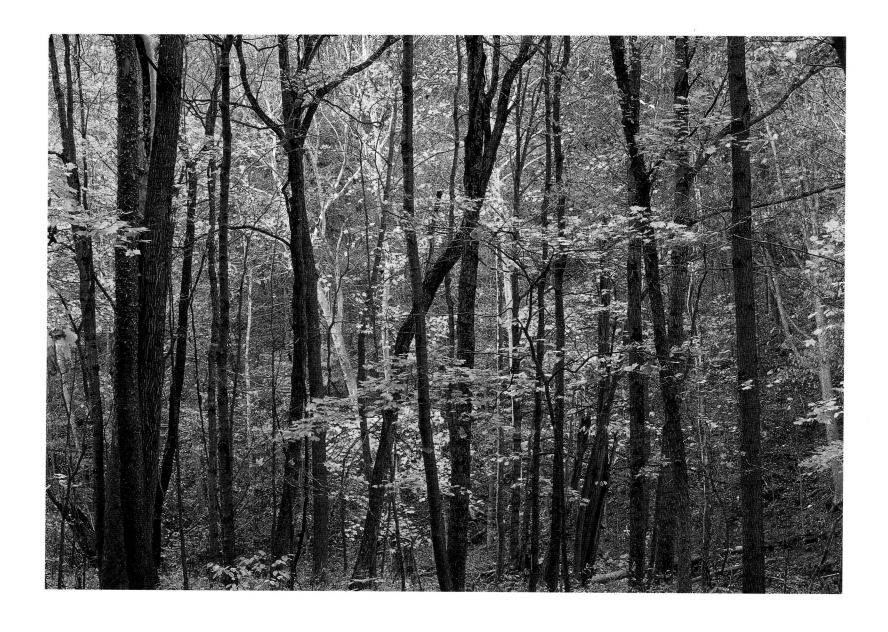

Autumn forest [CJ]

VERSAILLES STATE PARK

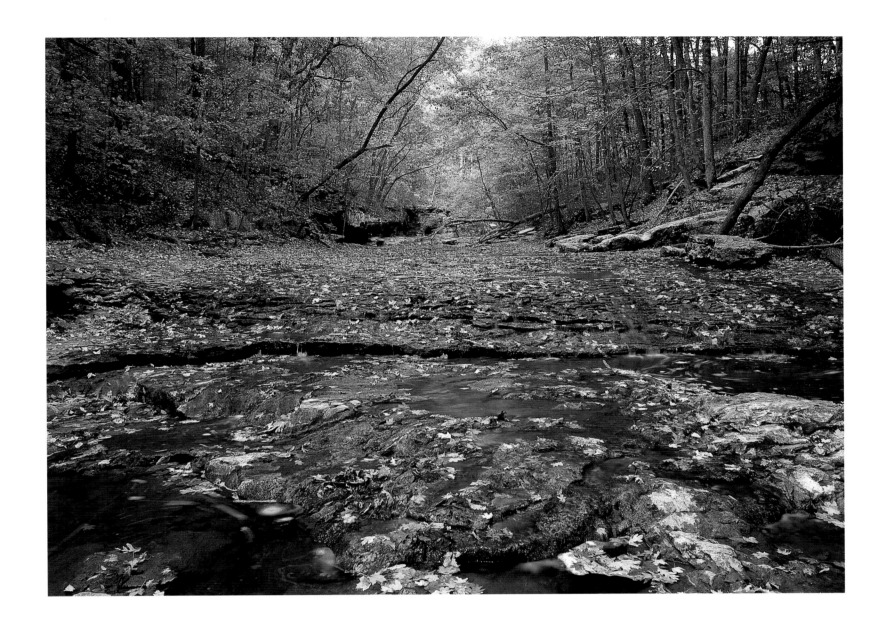

Fall colors along McCormick's Creek [CJ]

MᴄCᴏʀᴍɪᴄᴋ's Cʀᴇᴇᴋ Sᴛᴀᴛᴇ Pᴀʀᴋ

Frosted oak leaves are bathed in early morning light along Wildcat Creek [RL]

HOWARD COUNTY

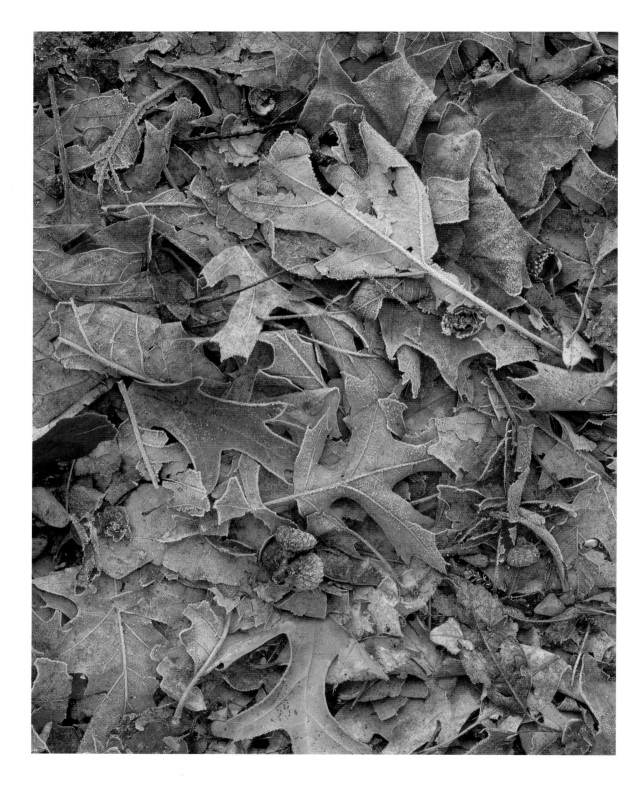

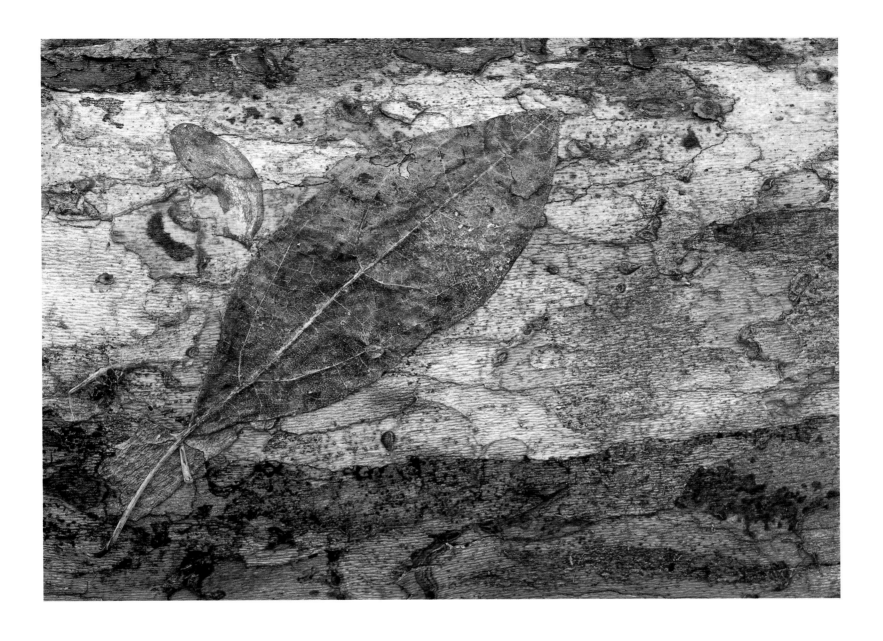

Abstract pattern of leaf and inner bark [CJ]

MUSCATATUCK NATIONAL WILDLIFE REFUGE

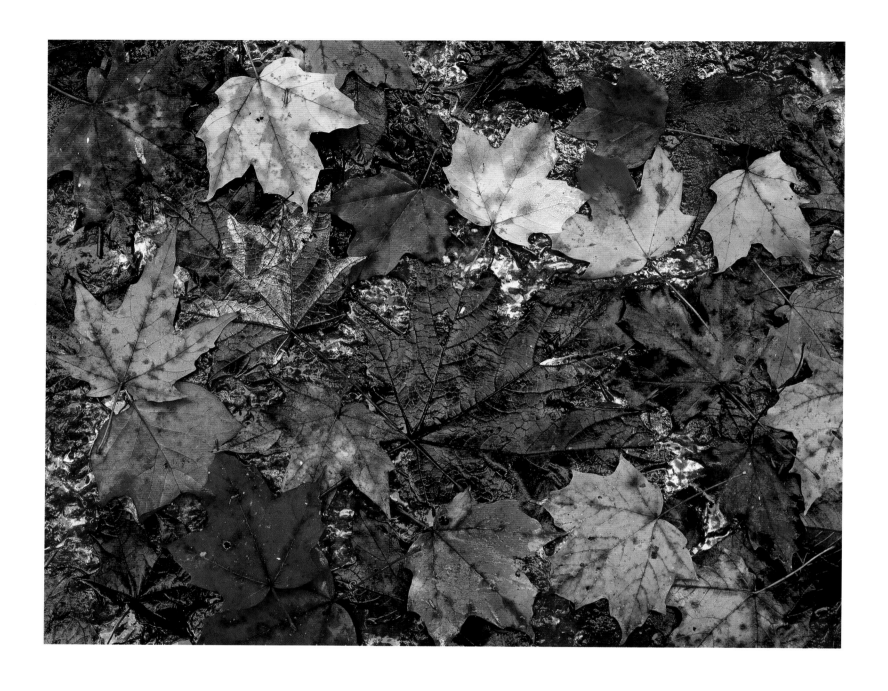

Fall color contrasts against the sandstone canyon walls of Rocky Hollow–Falls Canyon Nature Preserve [RL]

TURKEY RUN STATE PARK

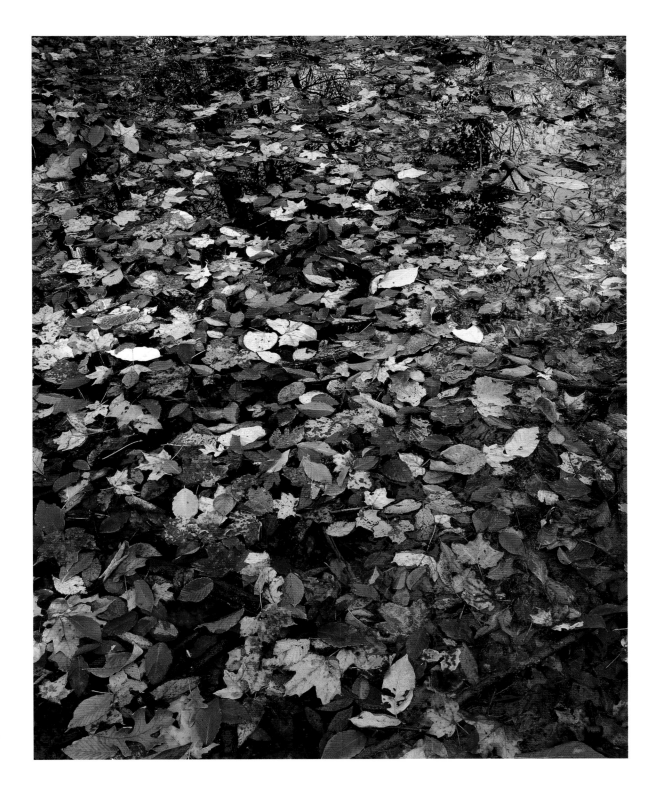

Fall leaves create a colorful collage [RL]

Hoosier National Forest

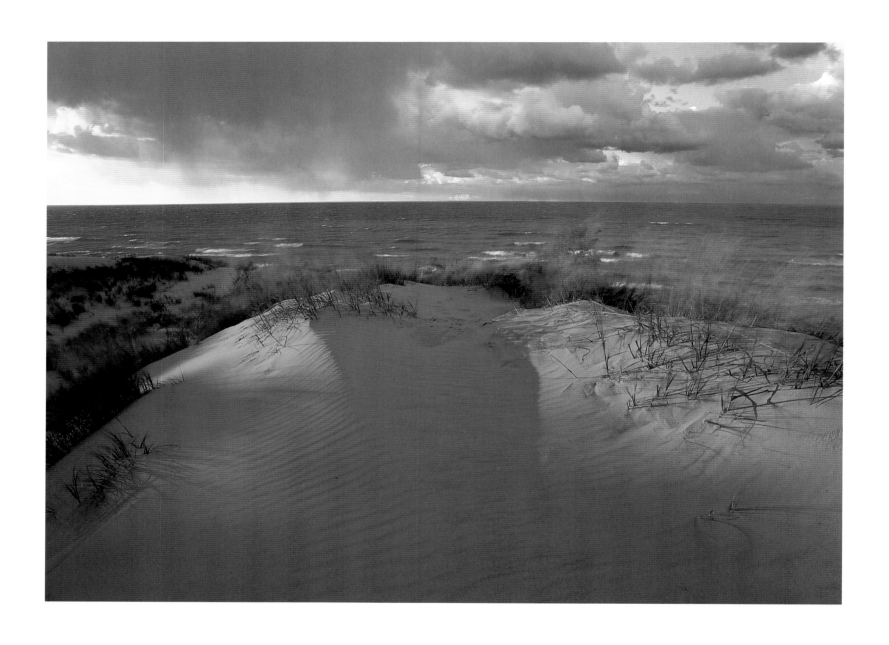

A clearing storm lights the dunes at Mt. Baldy [CJ]

INDIANA DUNES NATIONAL LAKESHORE

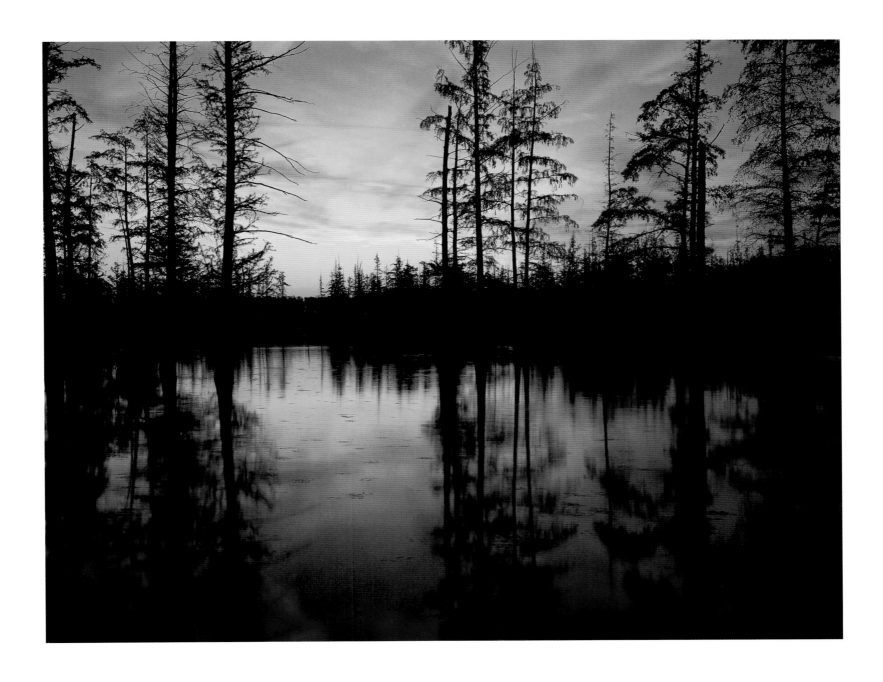

A fiery sunrise silhouettes the bald cypress of Hovey Lake [RL]

HOVEY LAKE FISH & WILDLIFE AREA

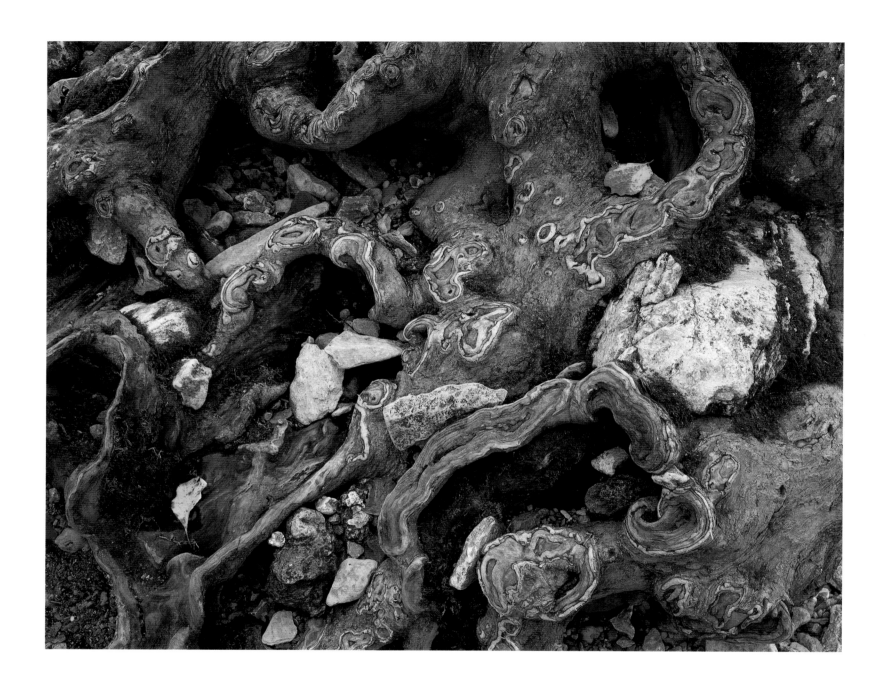

Detail of a sycamore's roots along Big Clifty Creek [RL]

CLIFTY FALLS STATE PARK

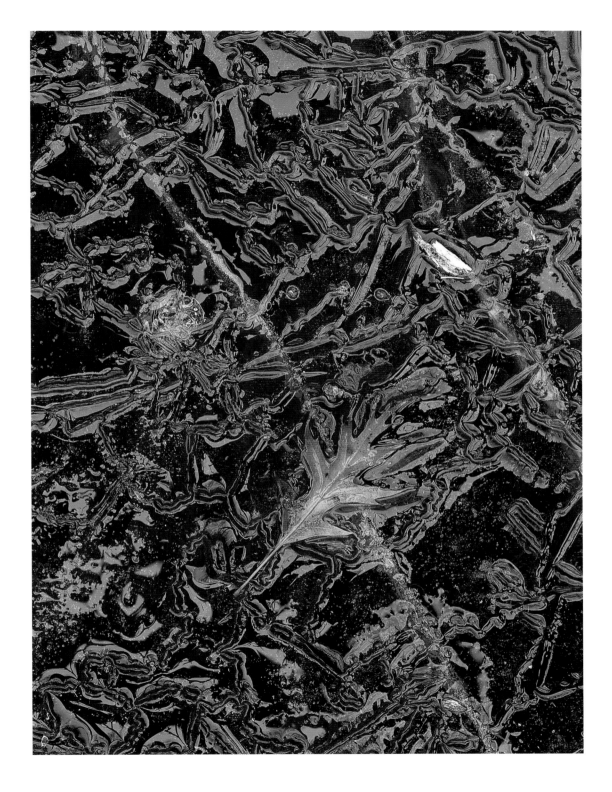

Oak leaf frozen in ice [CJ]

MUSCATATUCK NATIONAL
WILDLIFE REFUGE

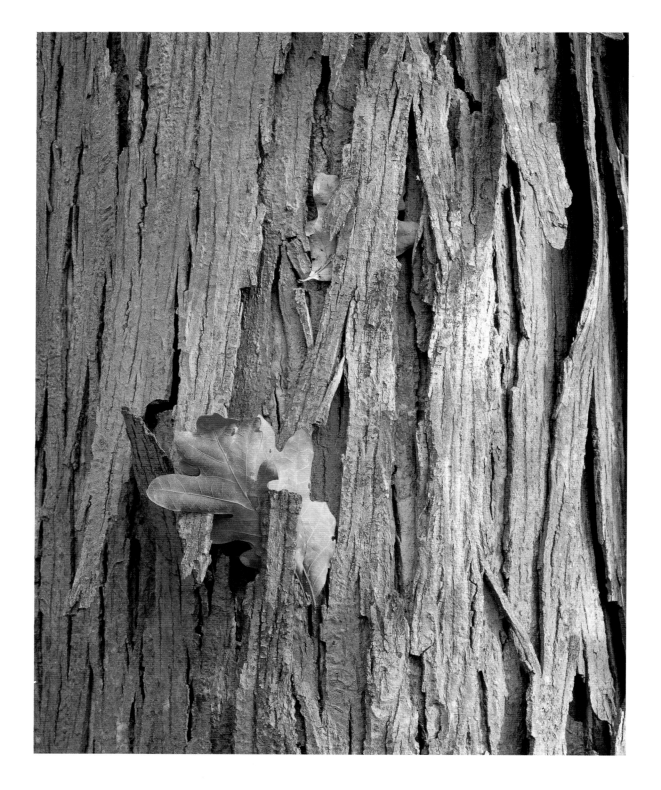

Leaves are captured by a shagbark hickory [RL]

NOBLE COUNTY

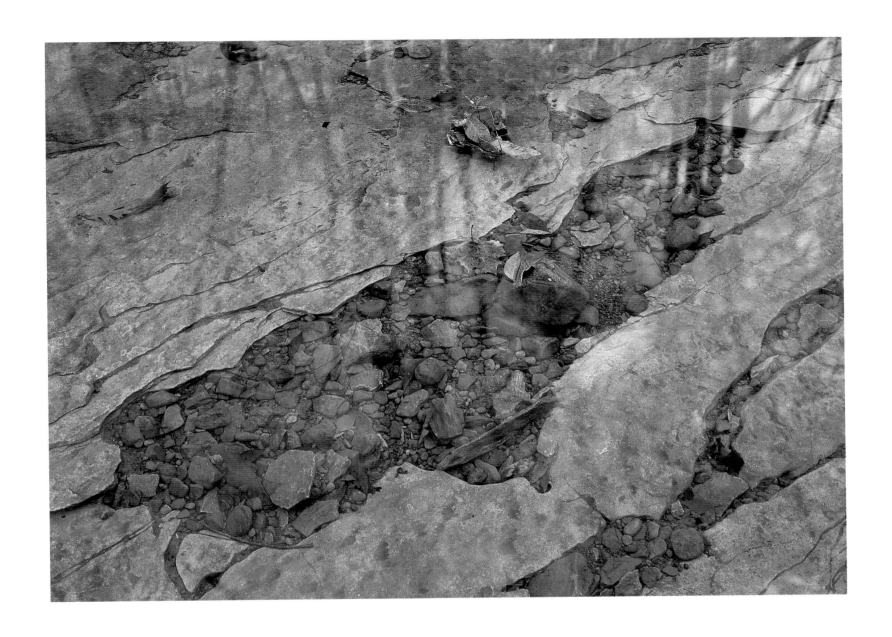

Sky and fall colors reflect in a rocky streambed [CJ]

YELLOW BIRCH RAVINE NATURE PRESERVE

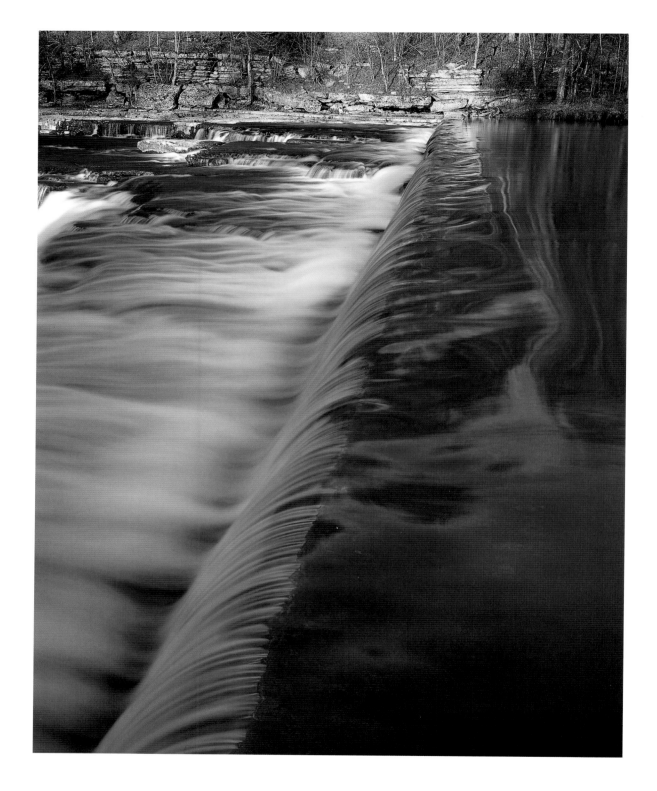

*Late day light paints Mill Creek above
Cataract Falls* [RL]

CATARACT FALLS STATE
RECREATION AREA

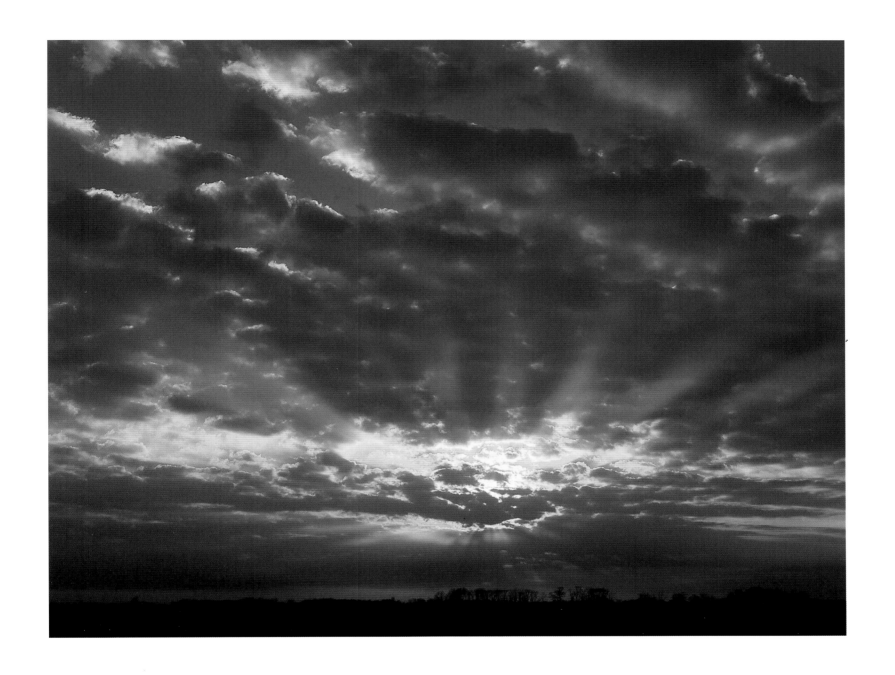

A dramatic cloud bank lights up just before sunset [CJ]

MONTGOMERY COUNTY

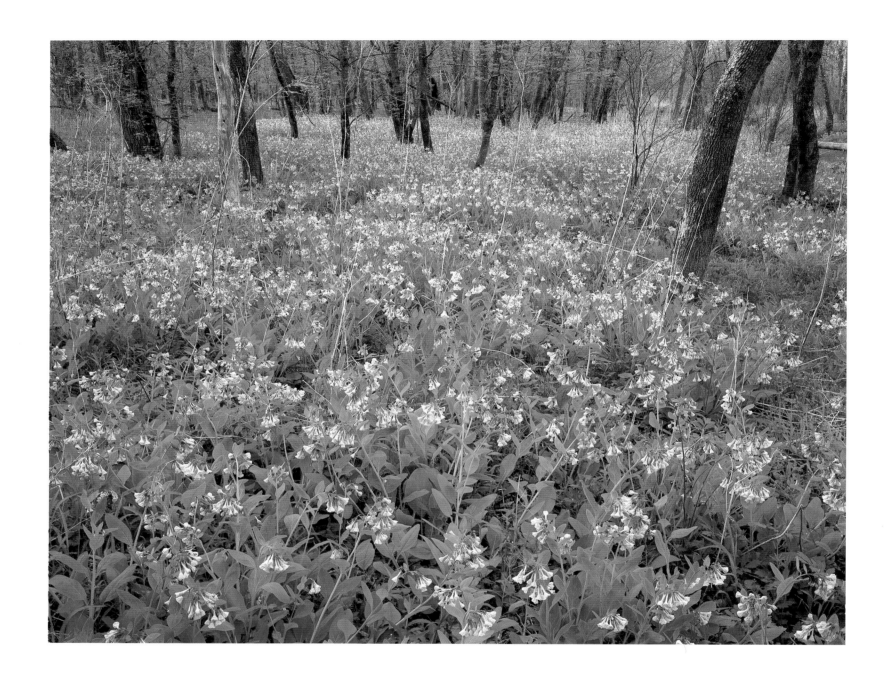

Virginia bluebells blanket the forest floor [RL]

VERSAILLES STATE PARK

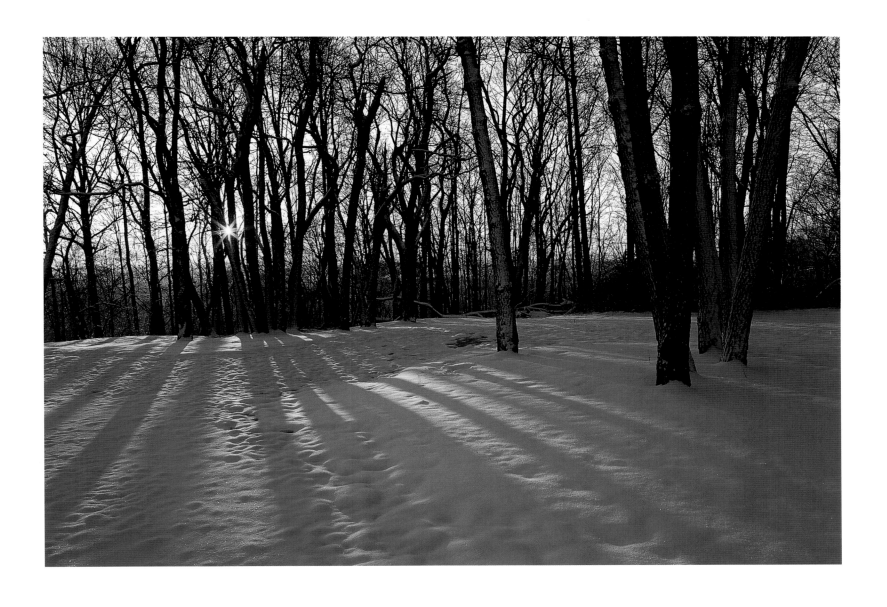

Sunrise throws shadows over a forested ridge top [CJ]

BROWN COUNTY STATE PARK

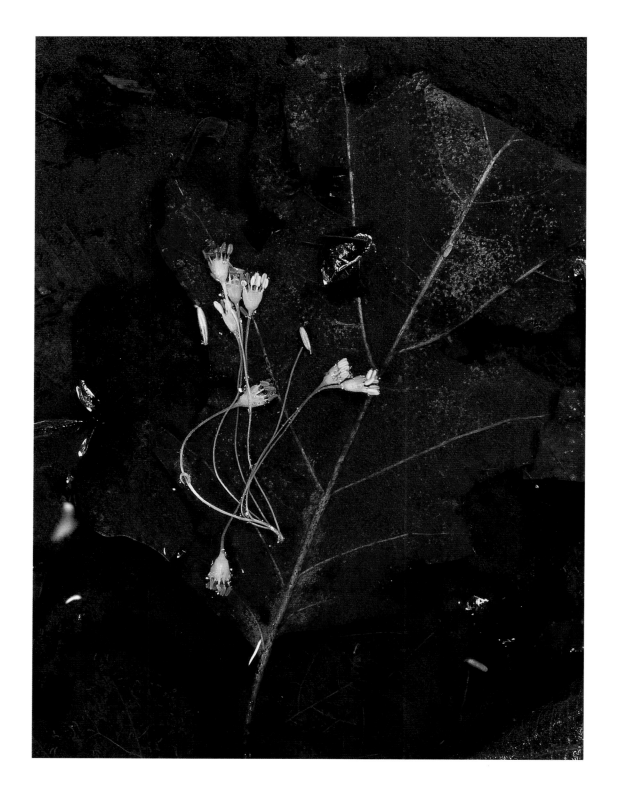

Sugar maple blossom resting
on an oak leaf [CJ]

SHADES STATE PARK

Oils from decaying plants form a kaleidoscope of color [CJ]

YELLOWWOOD STATE FOREST

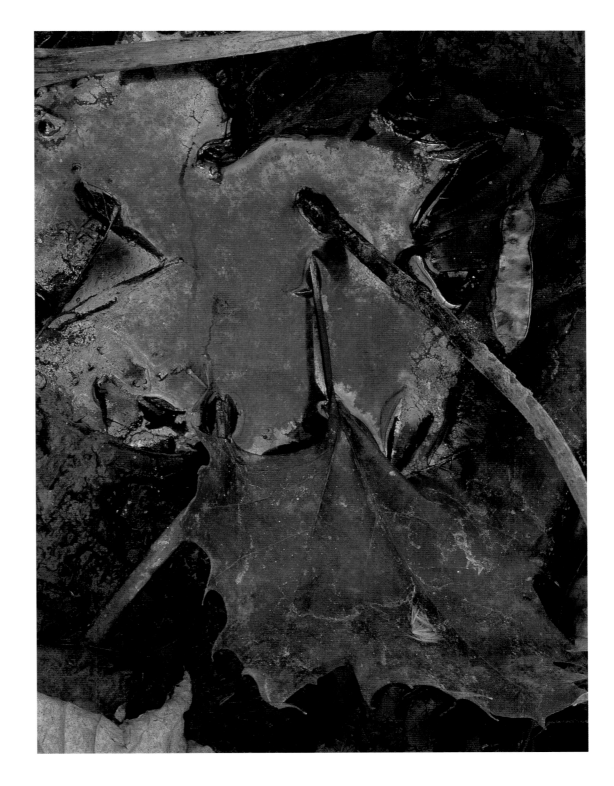

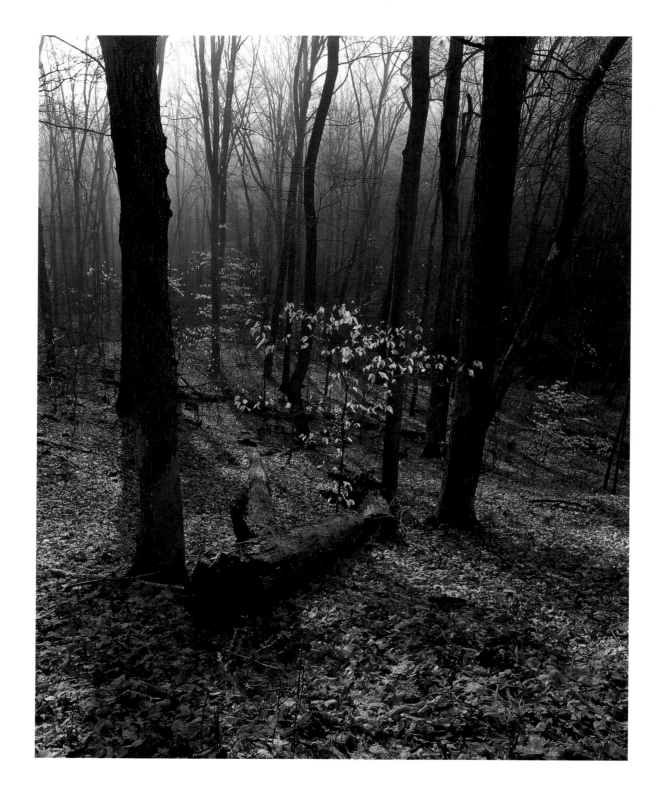

*Morning sun filters through
the mist in late winter* [CJ]

CHARLES C. DEAM WILDERNESS,
HOOSIER NATIONAL FOREST

A mossy tree trunk in a snow-covered forest [CJ]

MORGAN COUNTY

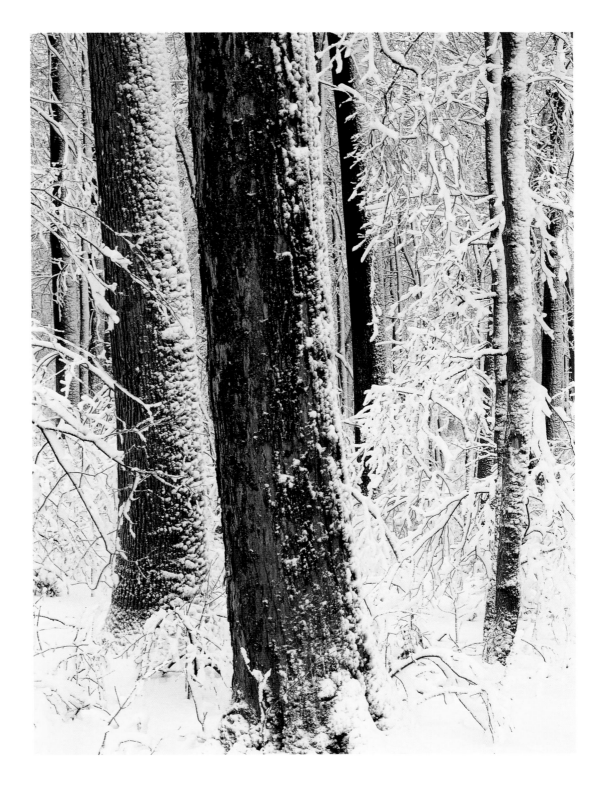

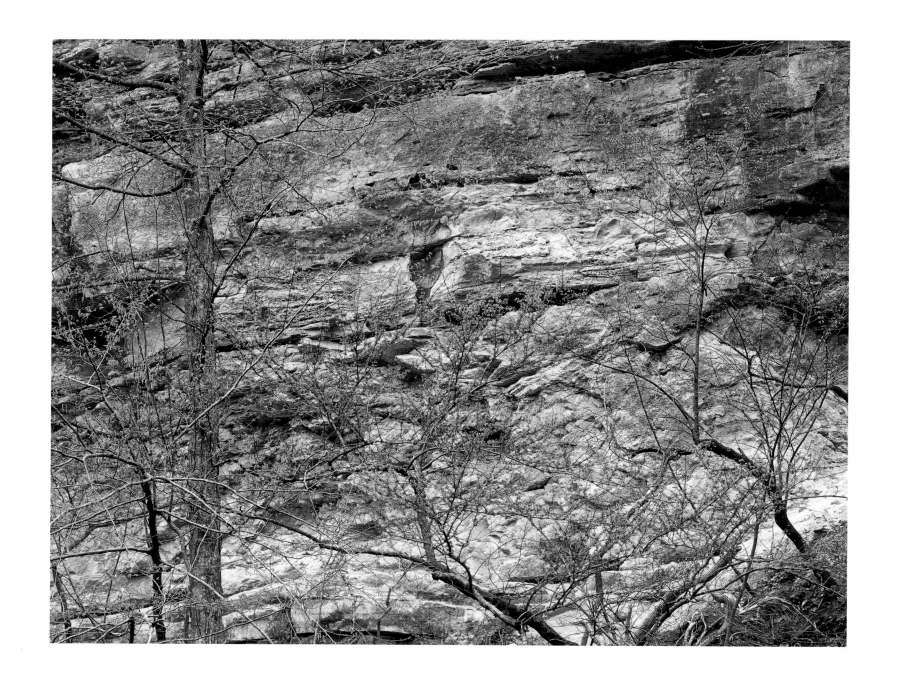

Flowering redbud trees add delicate color to harsh canyon walls [RL]

McCormick's Creek State Park

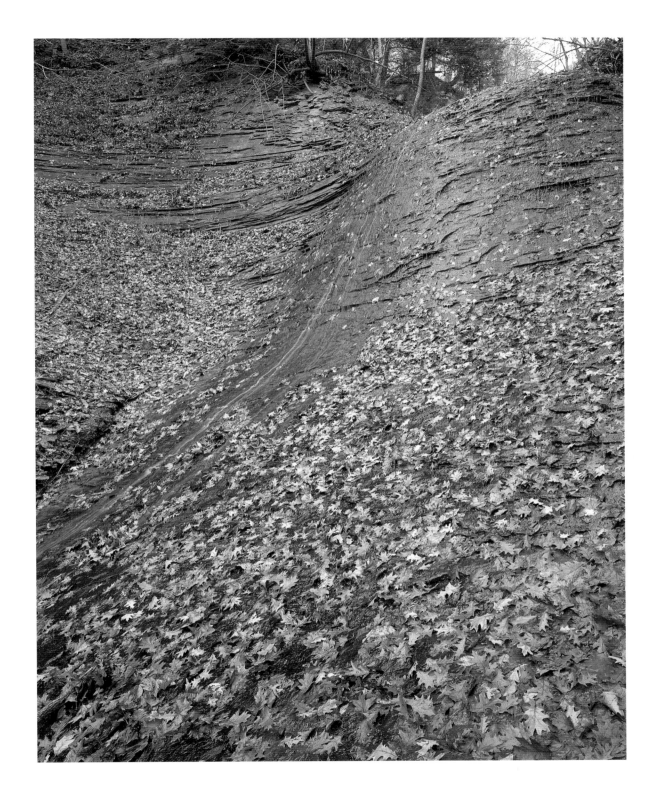

Fallen oak leaves accent
Silver Cascade Falls [RL]

SHADES STATE PARK

69

Bald cypress trees flourish at the northernmost edge of their natural range in southern Indiana [RL]

Twin Swamps Nature Preserve

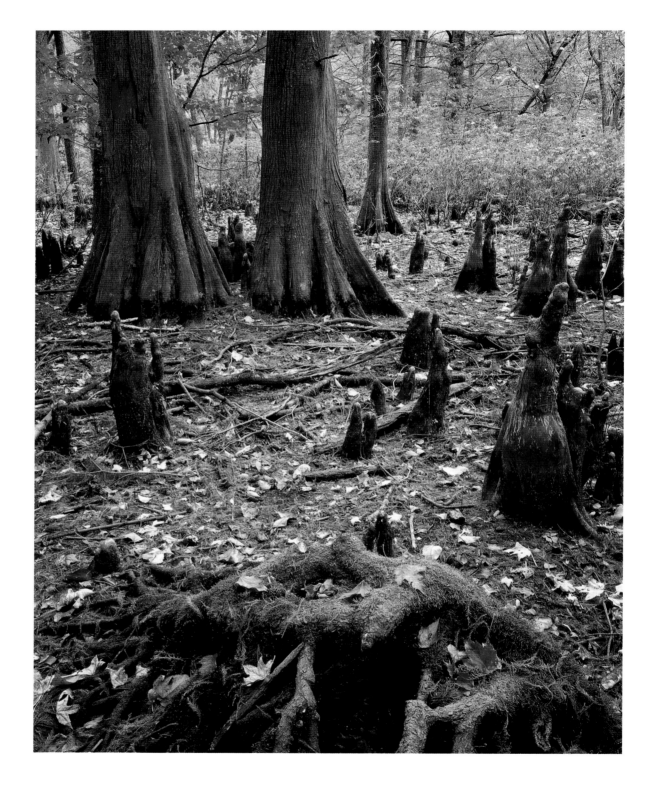

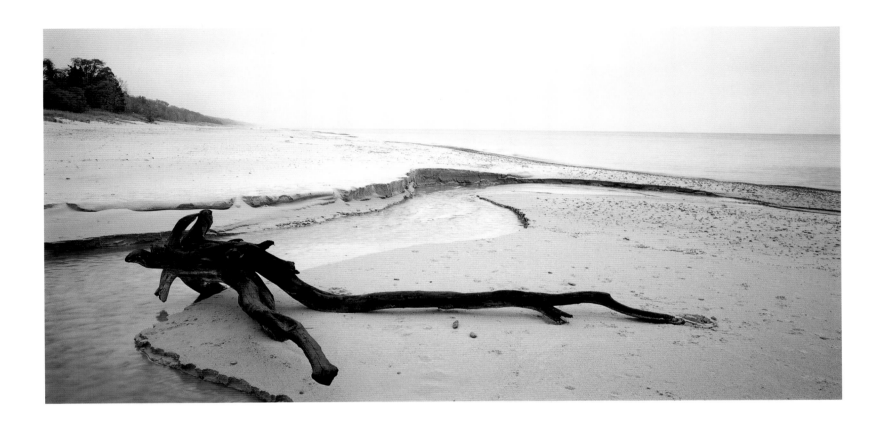

A view of Lake Michigan from Kemil Beach [RL]

INDIANA DUNES NATIONAL LAKESHORE

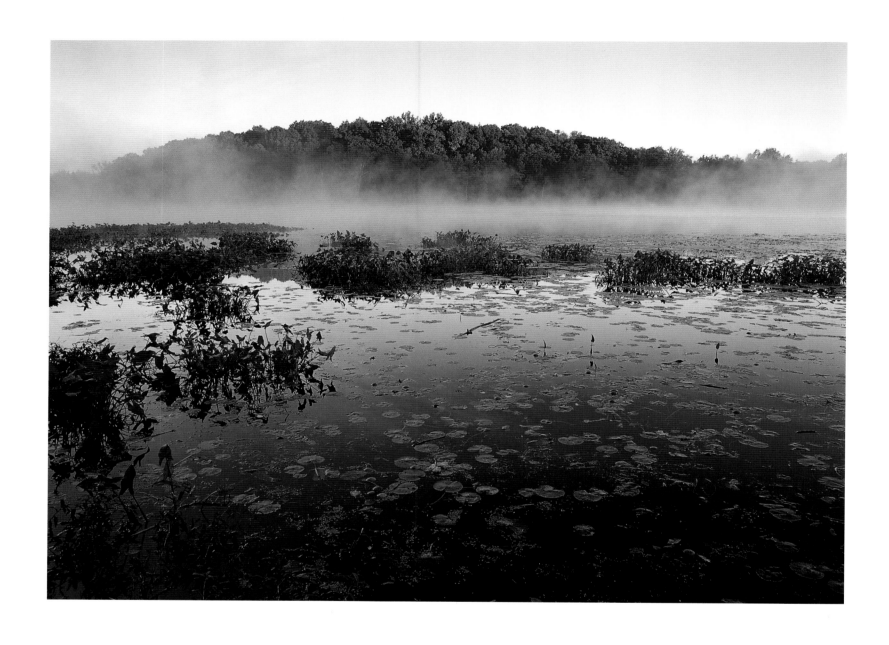

Sunrise touches the trees bordering Sand Lake [CJ]

CHAIN O' LAKES STATE PARK

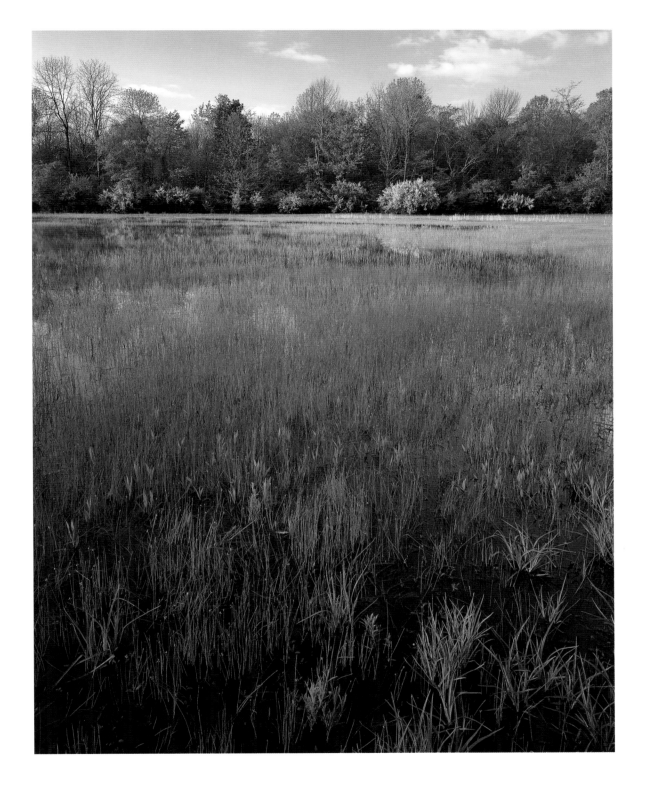

A vernal pool in Spring Pond
Nature Preserve [CJ]

EAGLE CREEK PARK

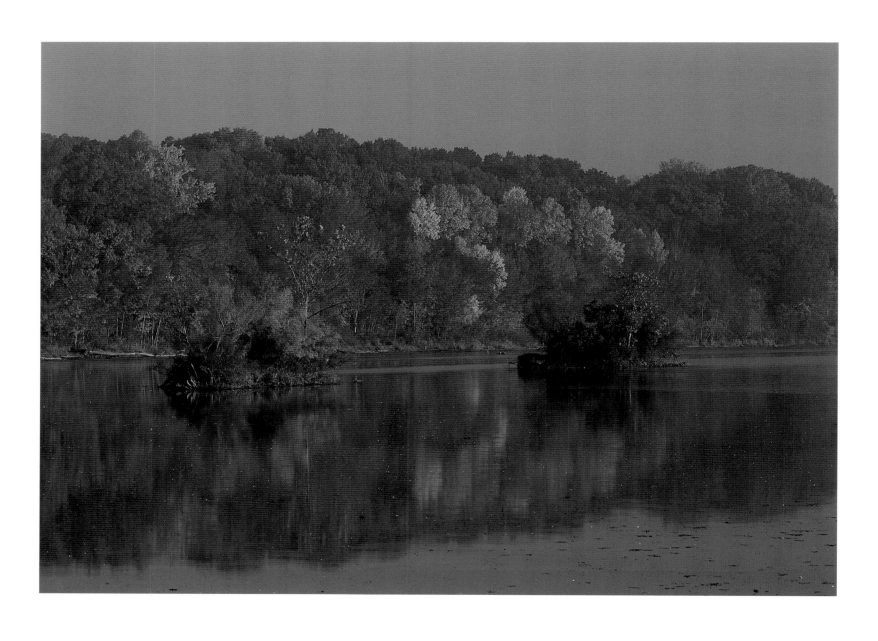

Misty morning light on the shore of Eagle Creek Reservoir [CJ]

EAGLE CREEK PARK

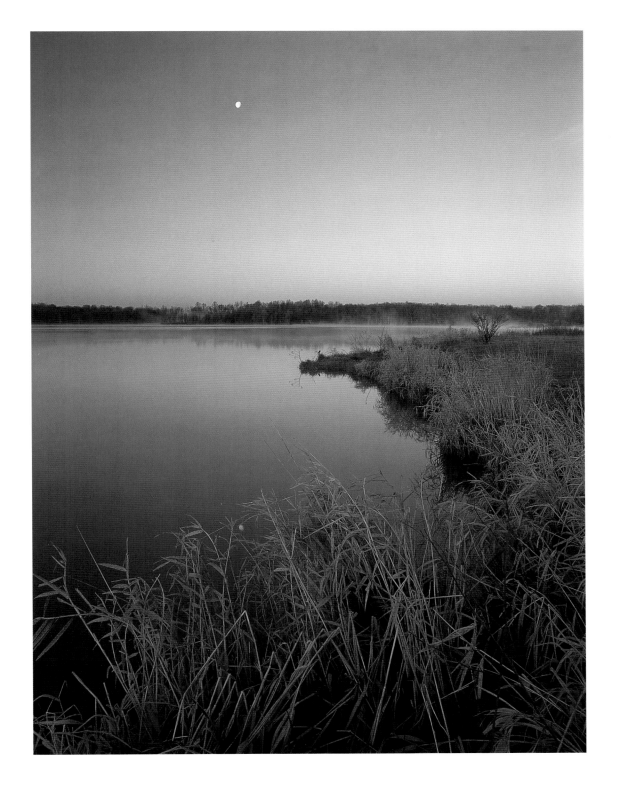

*Dawn breaks over Worster Lake
in early spring* [CJ]

POTATO CREEK STATE PARK

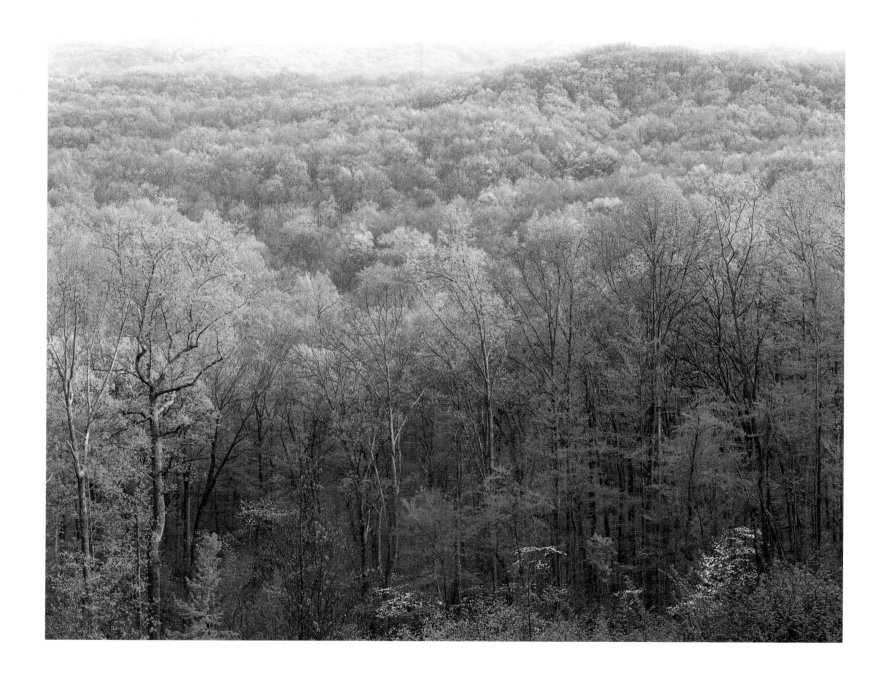

Among the rolling hills of Brown County, early spring takes on a delicate look [RL]

BROWN COUNTY STATE PARK

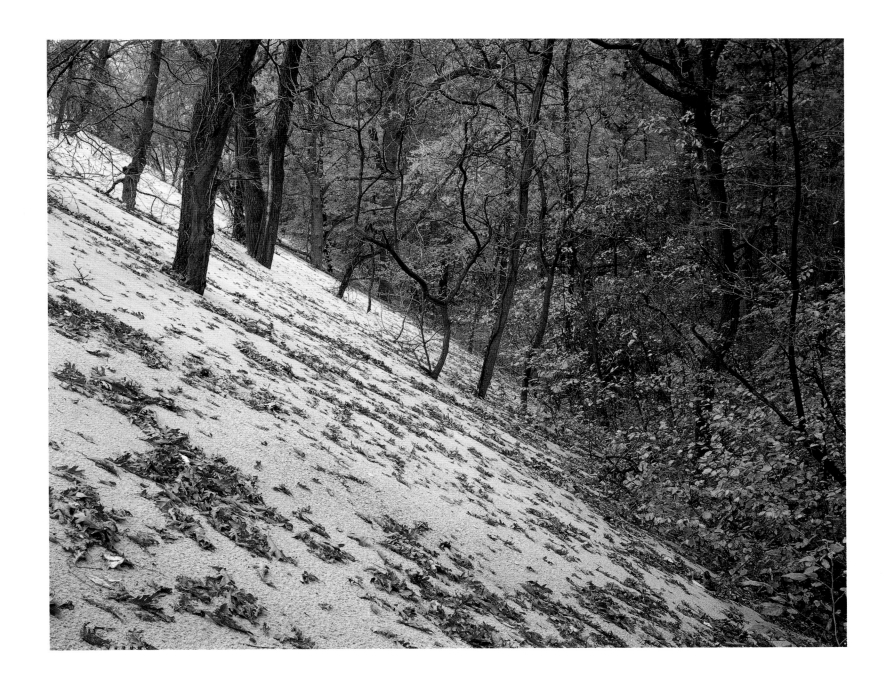

Driven by lake winds, Mt. Baldy overtakes the bordering forest [RL]

INDIANA DUNES NATIONAL LAKESHORE

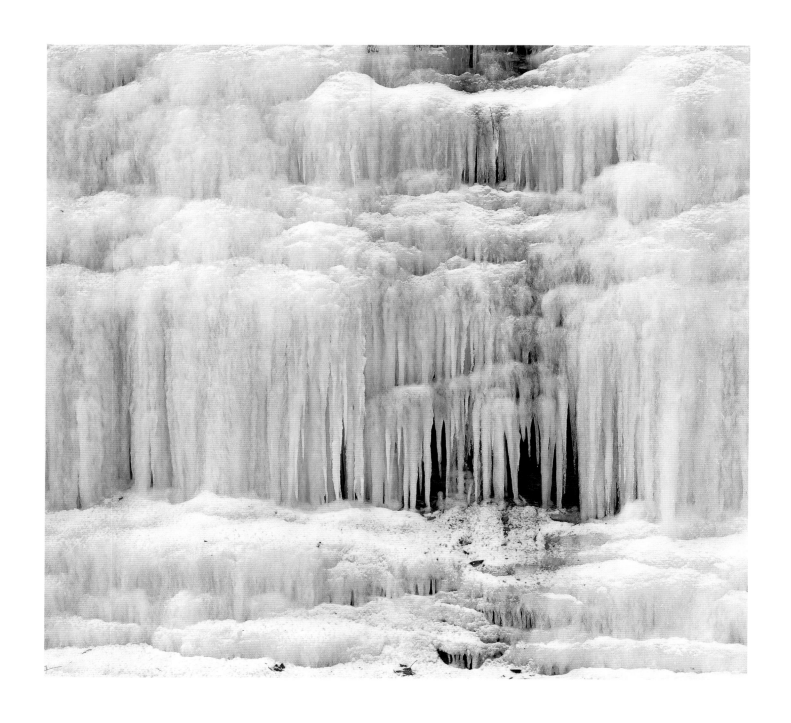

An ice sheet covers a cliff face along Clifty Creek [CJ]

CLIFTY FALLS STATE PARK

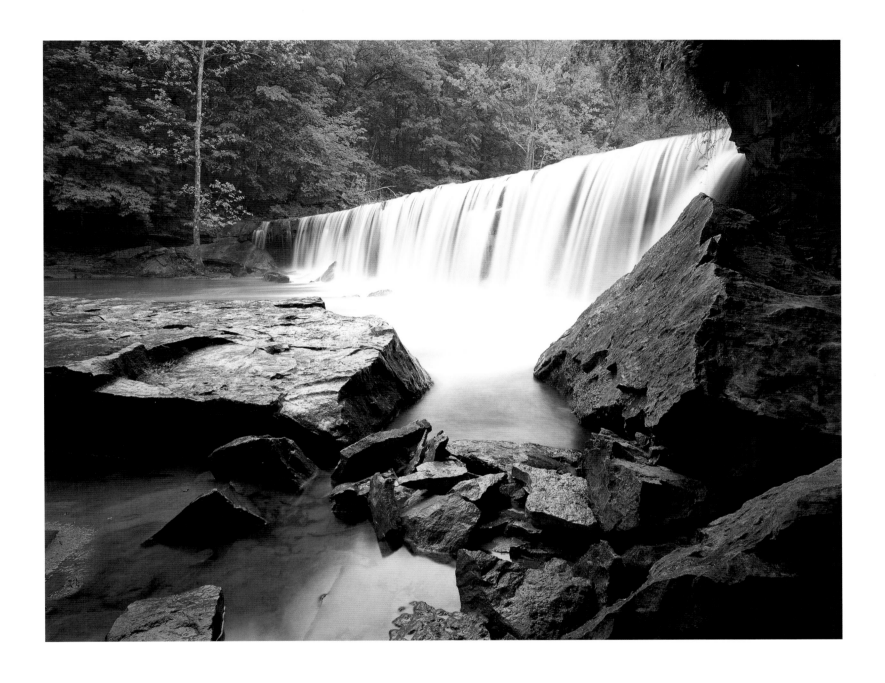

In Bartholomew County, the Middle Fork of Clifty Creek drops some fifteen feet as Anderson Falls [RL]

ANDERSON FALLS NATURE PRESERVE

Green and yellow leaves frozen in a thick layer of ice [CJ]

Muscatatuck National Wildlife Refuge

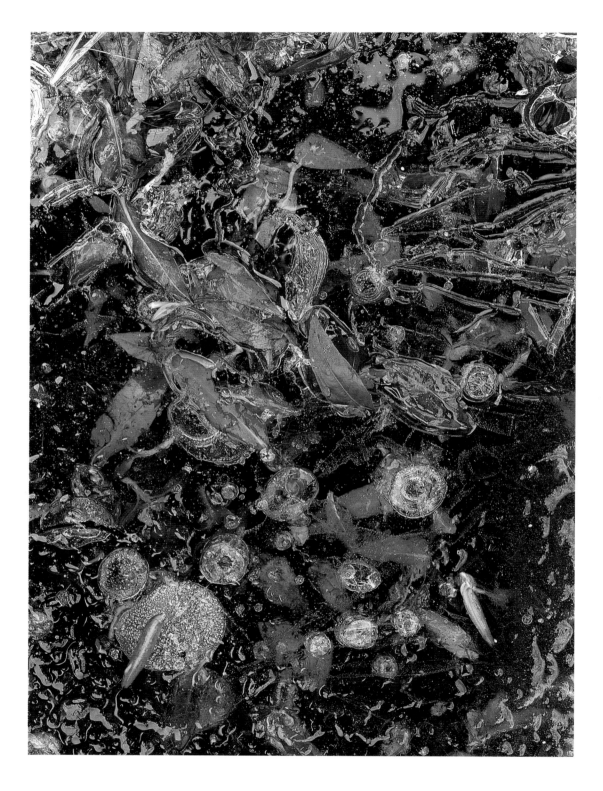

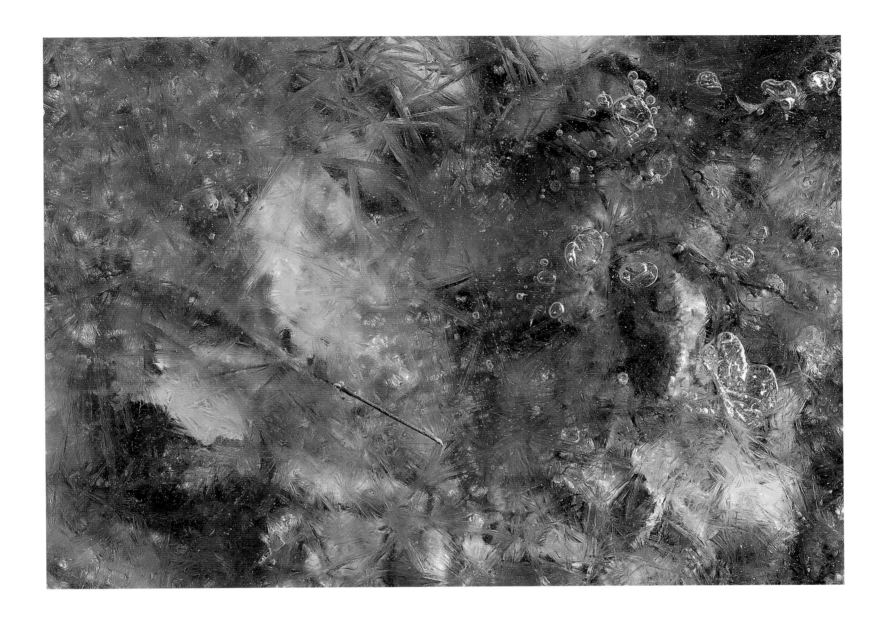

A sycamore leaf frozen in a small stream [CJ]

CLIFTY FALLS STATE PARK

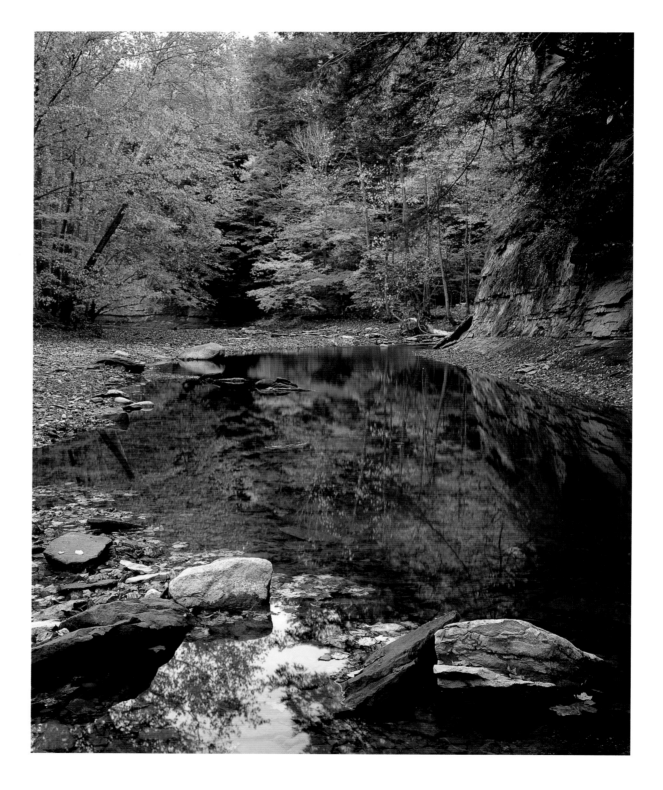

Late evening shadows and reflections [CJ]

PINE HILLS NATURE PRESERVE

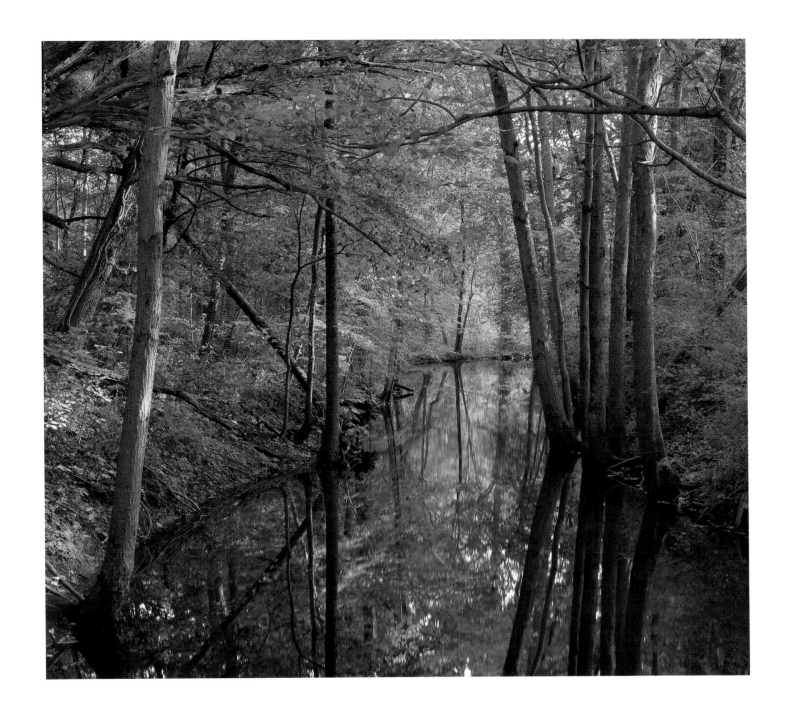

Afternoon sun lights the glacial channel connecting Bowen and Sand Lakes [CJ]

CHAIN O' LAKES STATE PARK

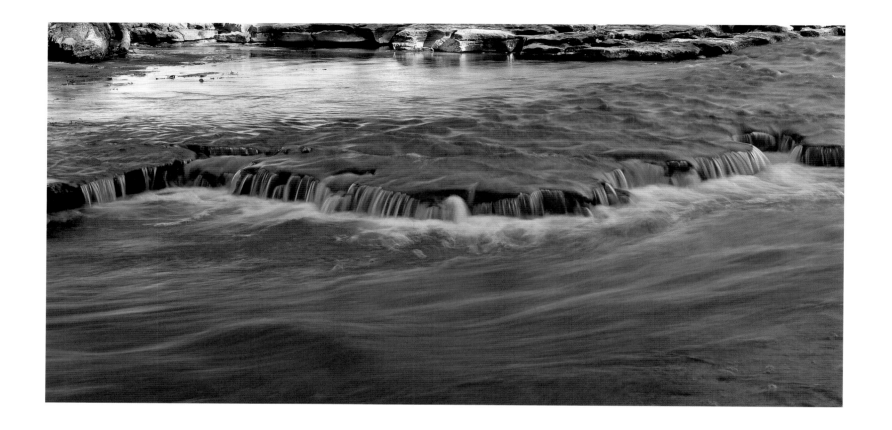

Fall colors reflecting in Mill Creek [CJ]

CATARACT FALLS STATE RECREATION AREA

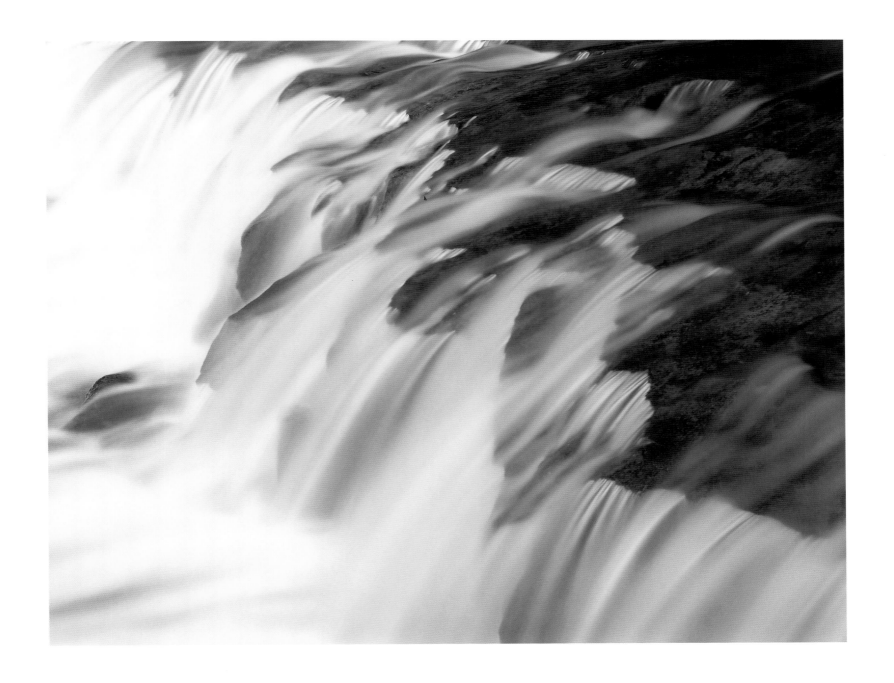

Close-up study of a waterfall [RL]

FALL CREEK GORGE NATURE PRESERVE

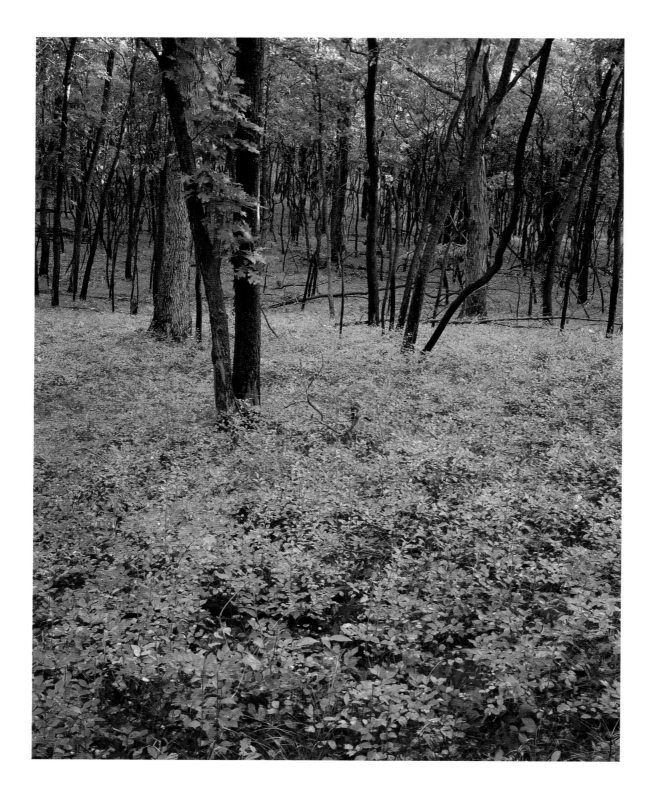

*Wild blueberry displays its fall color
along Cowles Bog Trail* [RL]

INDIANA DUNES
NATIONAL LAKESHORE

Morning light colors
Big Clifty Creek [RL]

CLIFTY FALLS STATE PARK

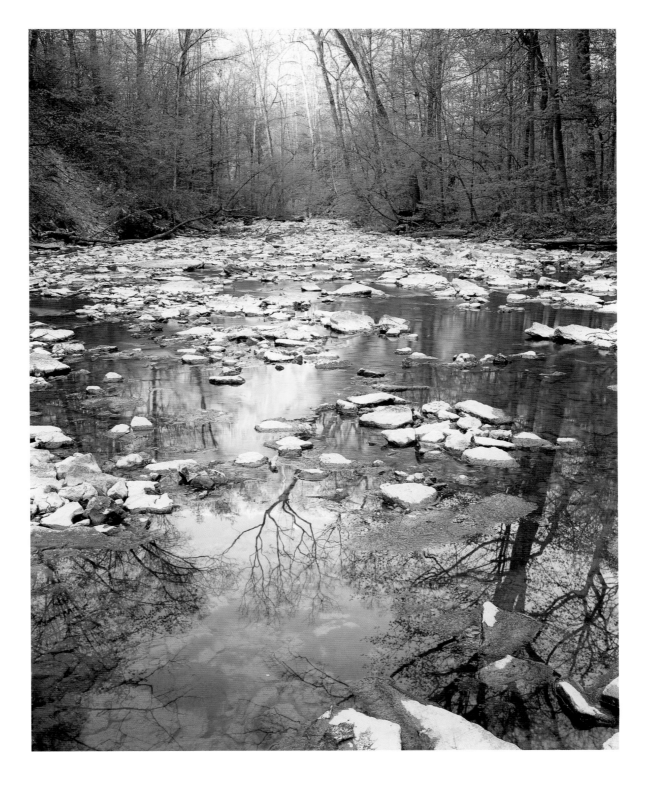

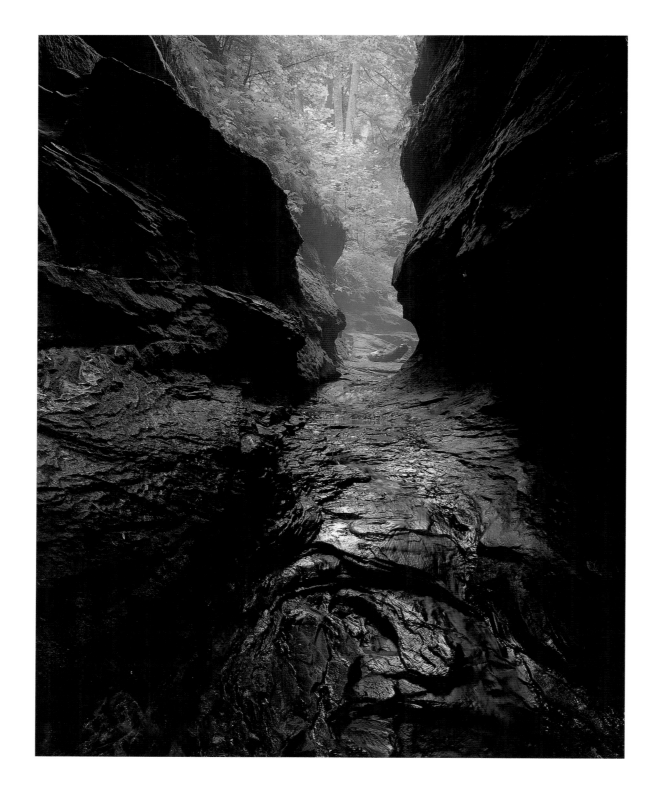

A view from an ancient
sandstone canyon [RL]

TURKEY RUN STATE PARK

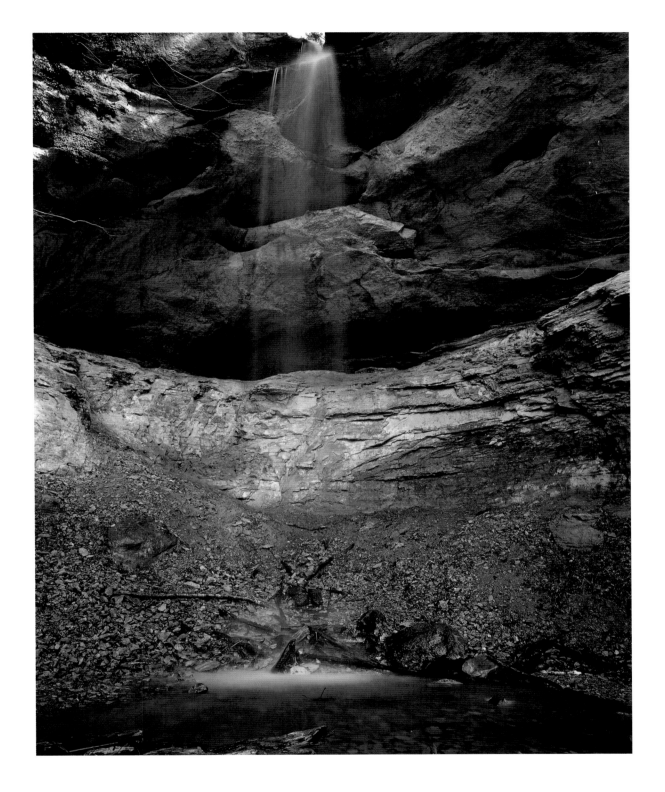

An unnamed waterfall [RL]

HEMLOCK CLIFFS
RECREATION AREA

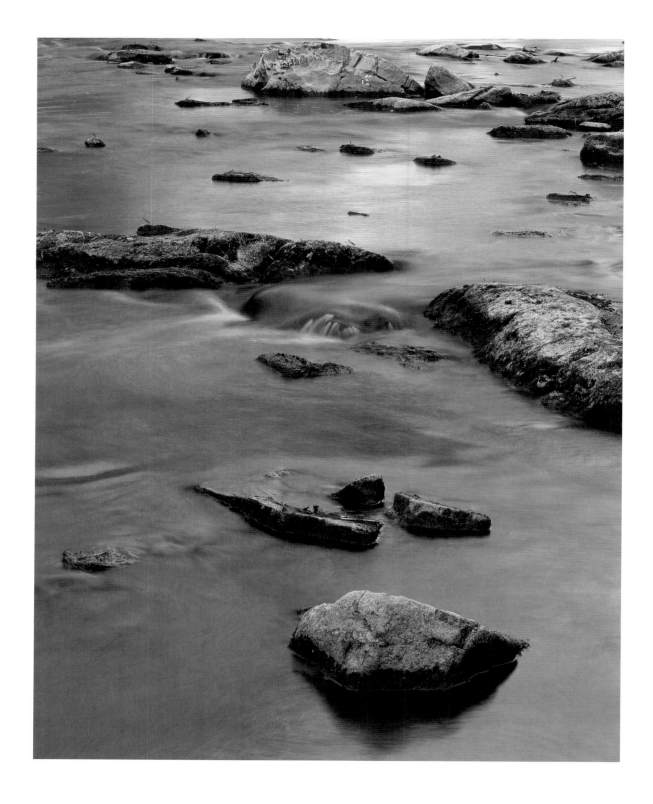

Canyon light reflects on
Mill Creek [RL]

CATARACT FALLS STATE
RECREATION AREA

Early light on snow-covered dunes and grasses [CJ]

INDIANA DUNES STATE PARK

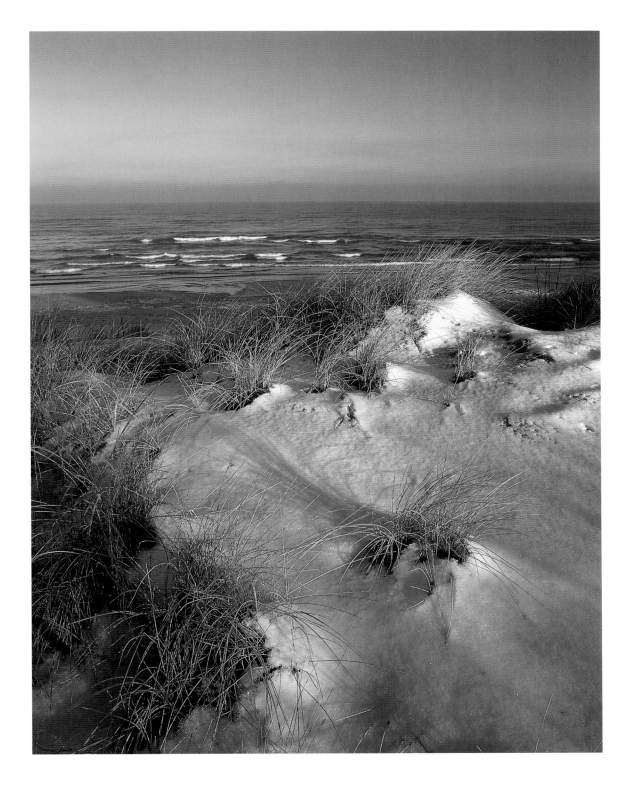

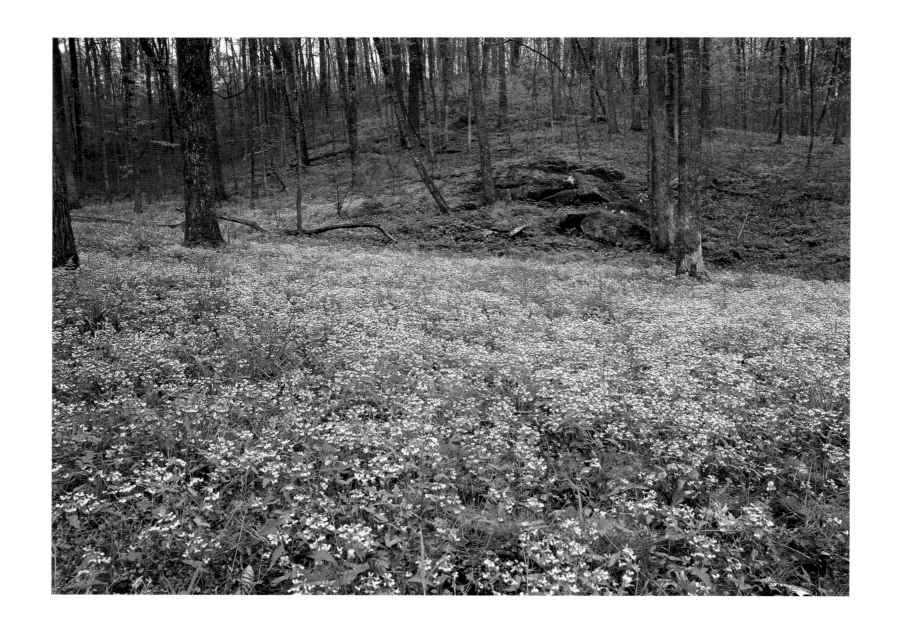

A carpet of blue-eyed Mary covers the forest floor [CJ]

Spring Mill State Park

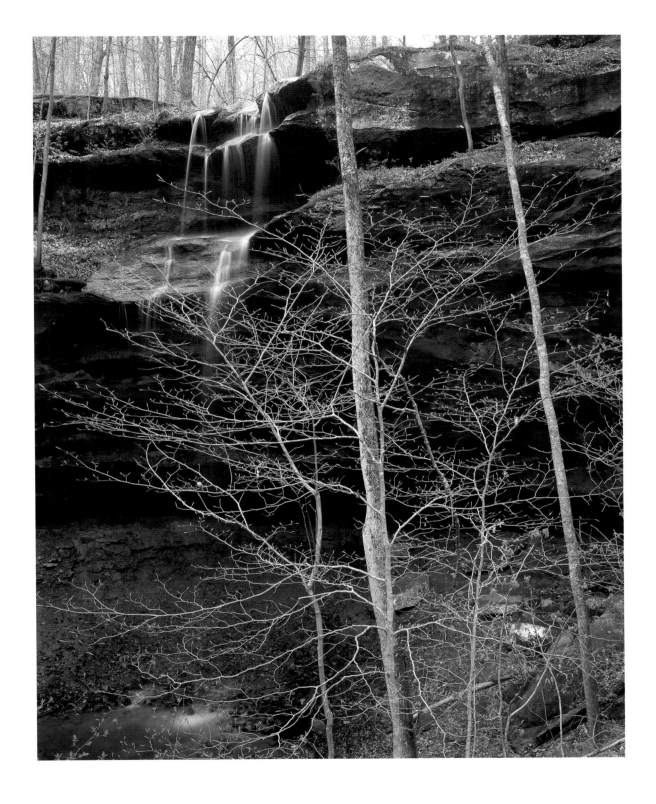

*A young beech tree greets spring
with its colorful buds* [RL]

HEMLOCK CLIFFS
RECREATION AREA

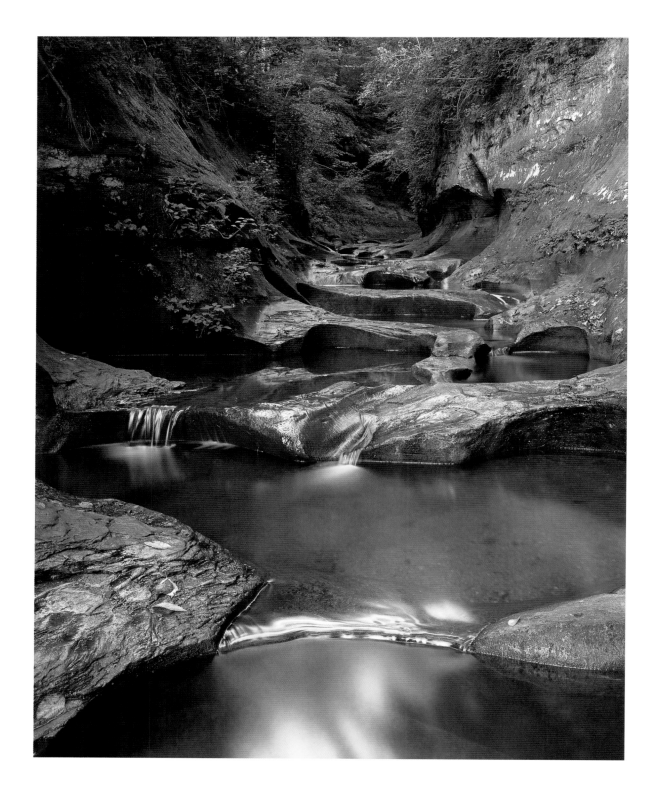

The cascading potholes of
Fall Creek [RL]

FALL CREEK GORGE
NATURE PRESERVE

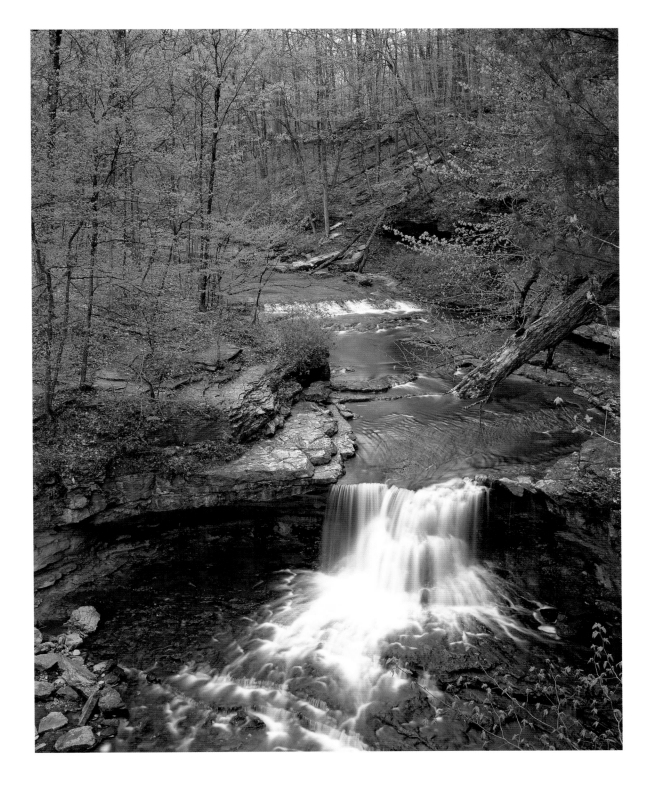

*A spring overview of McCormick's
Creek and its falls* [RL]

MCCORMICK'S CREEK STATE PARK

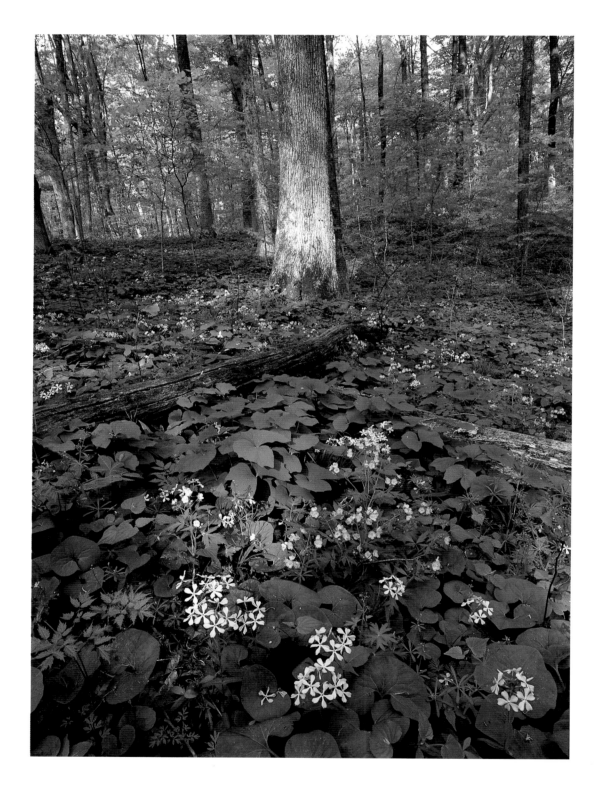

Spring wildflowers carpet the woods in
Wolf Cave Nature Preserve [CJ]

McCormick's Creek State Park

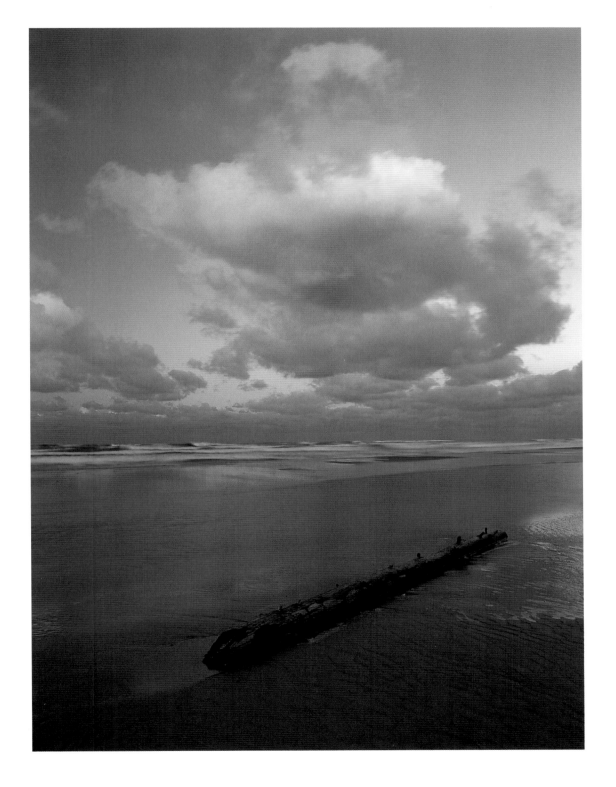

Sunset colors the clouds above
Lake Michigan [CJ]

INDIANA DUNES STATE PARK

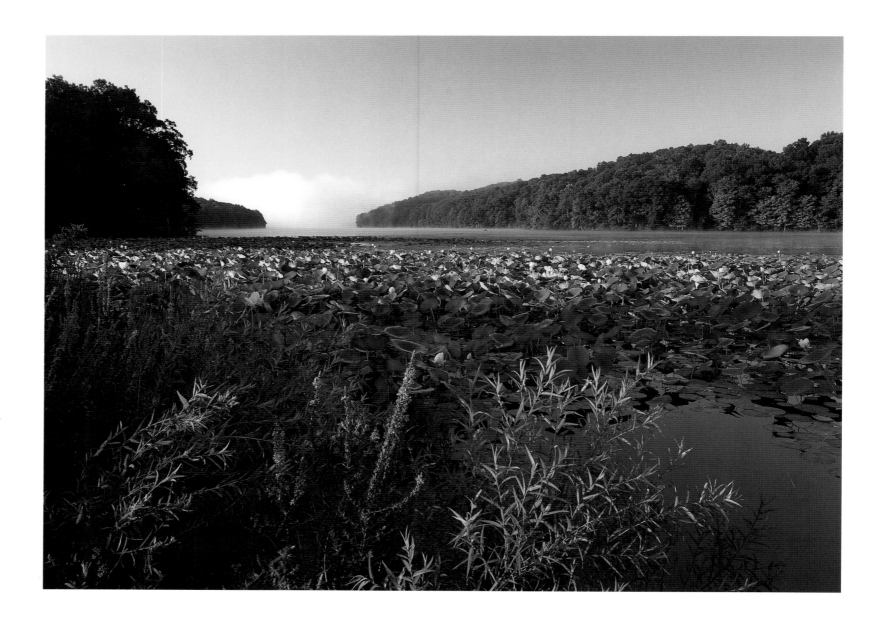

Sunrise on Yellowwood Lake [CJ]

YELLOWWOOD STATE FOREST

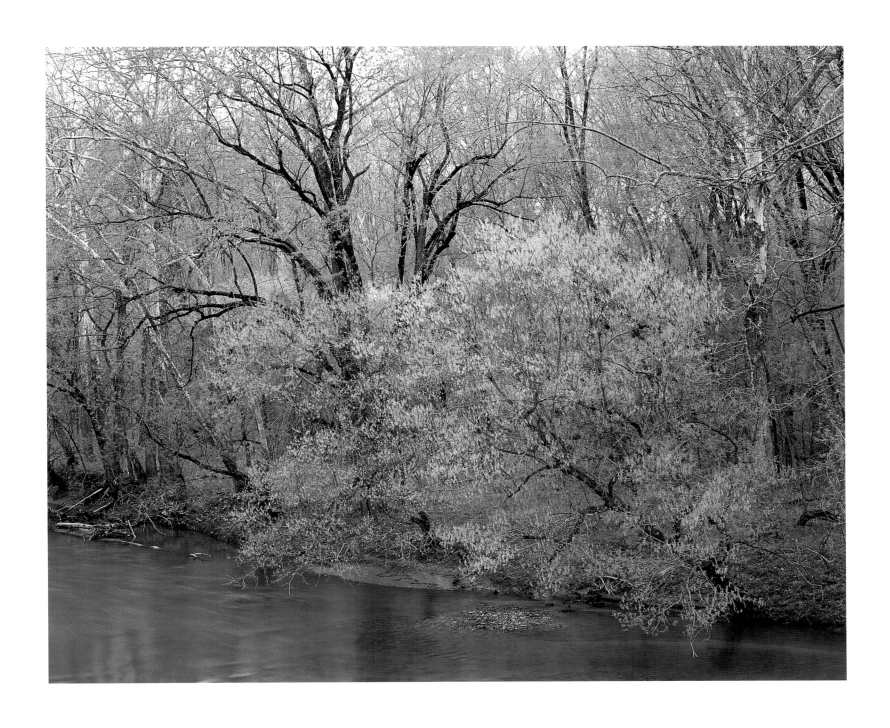

Early spring forest along Big Walnut Creek [CJ]

HALL WOODS NATURE PRESERVE

*Lichen-covered boulders accent
a small waterfall* [RL]

HEMLOCK CLIFFS
RECREATION AREA

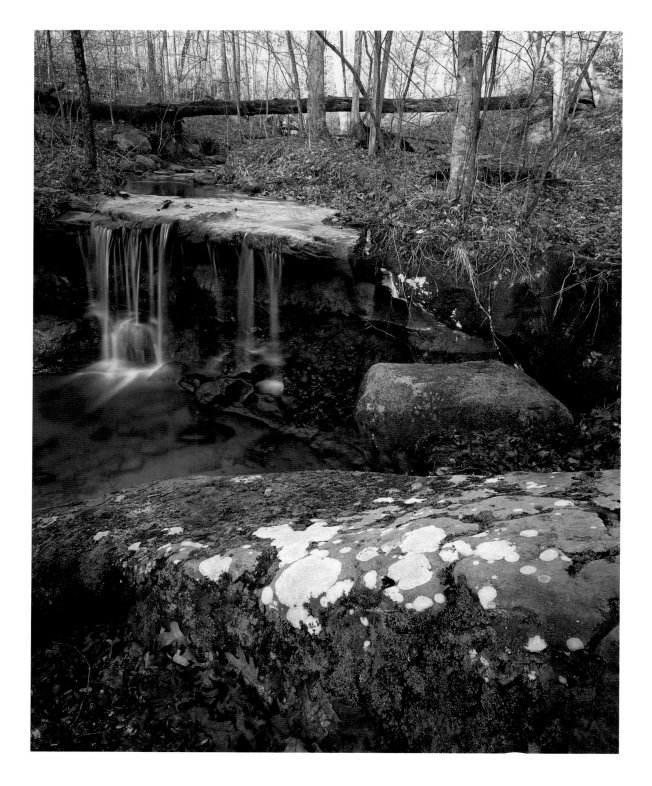

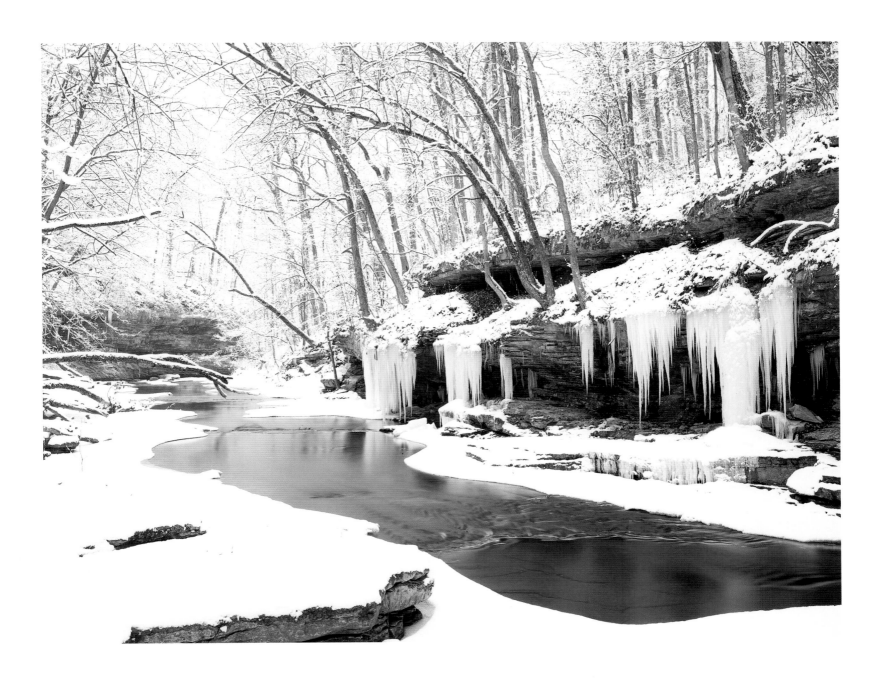

McCormick's Creek takes on the look of a winter wonderland [RL]

McCormick's Creek State Park

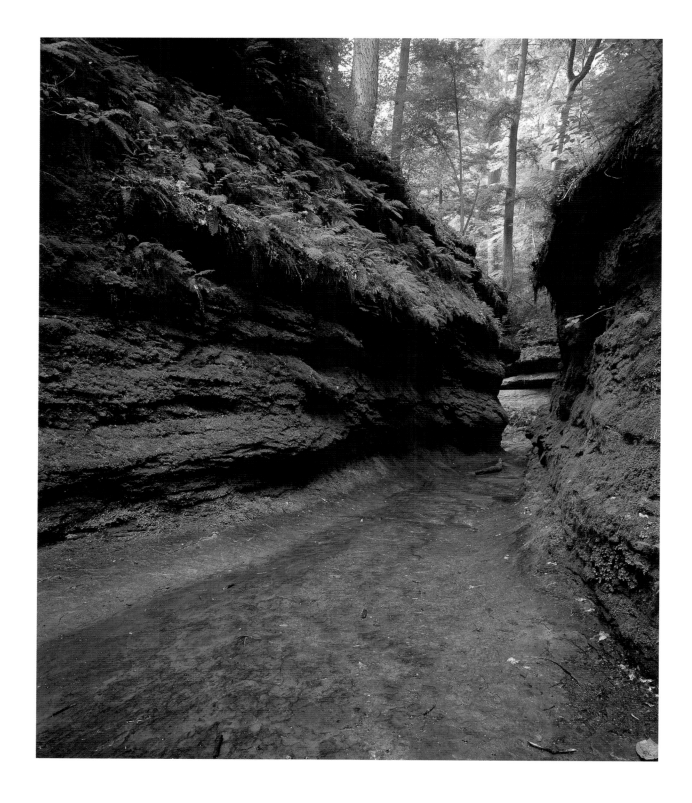

A fern- and lichen-covered canyon trail [RL]

TURKEY RUN STATE PARK

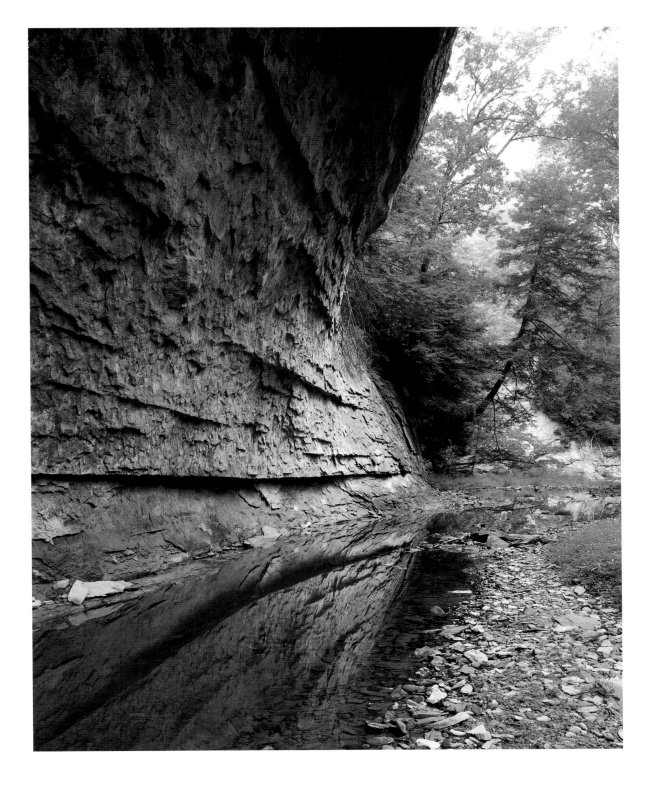

An incised meander known as the Devil's Backbone reflects onto Indian Creek [RL]

PINE HILLS NATURE PRESERVE

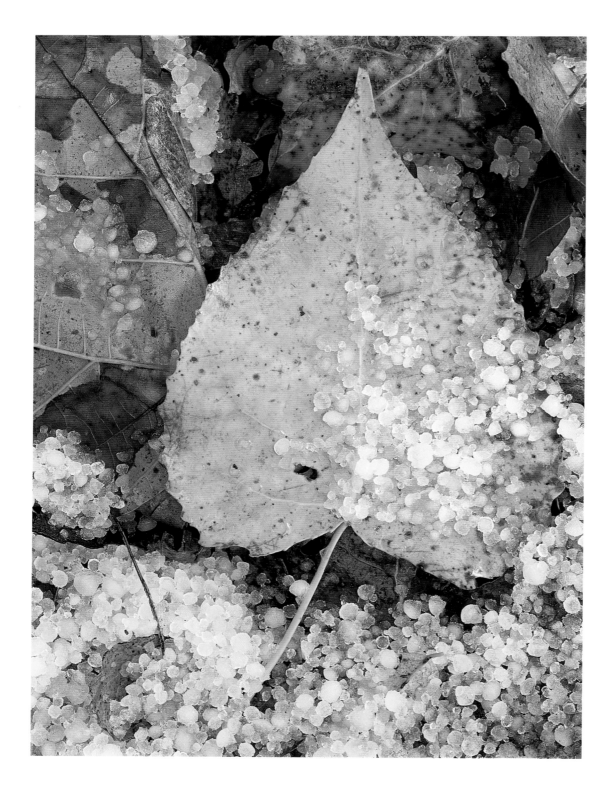

Yellow aspen leaf and hail [CJ]

INDIANA DUNES STATE PARK

Heavy fog surrounds a snag in
Stone Arch Lake [CJ]

ATTERBURY FISH & WILDLIFE AREA

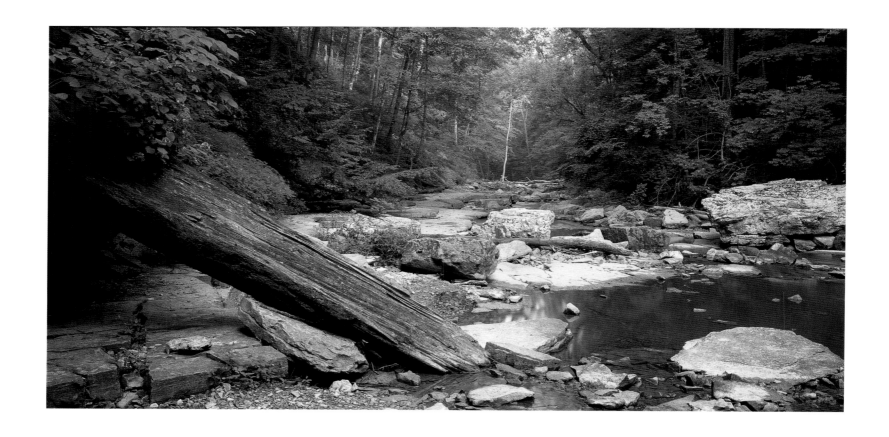

Dense hardwood forest lines a rocky McCormick's Creek [RL]

McCormick's Creek State Park

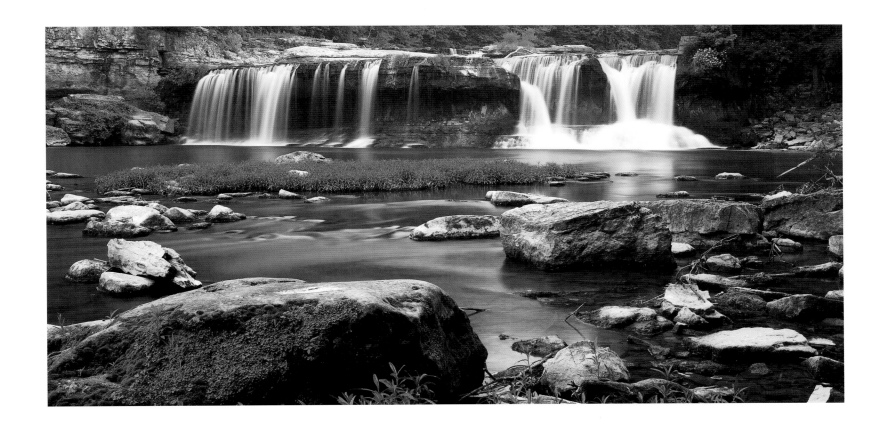

Upper Cataract Falls is one of the most impressive waterfalls in Indiana [RL]

CATARACT FALLS STATE RECREATION AREA

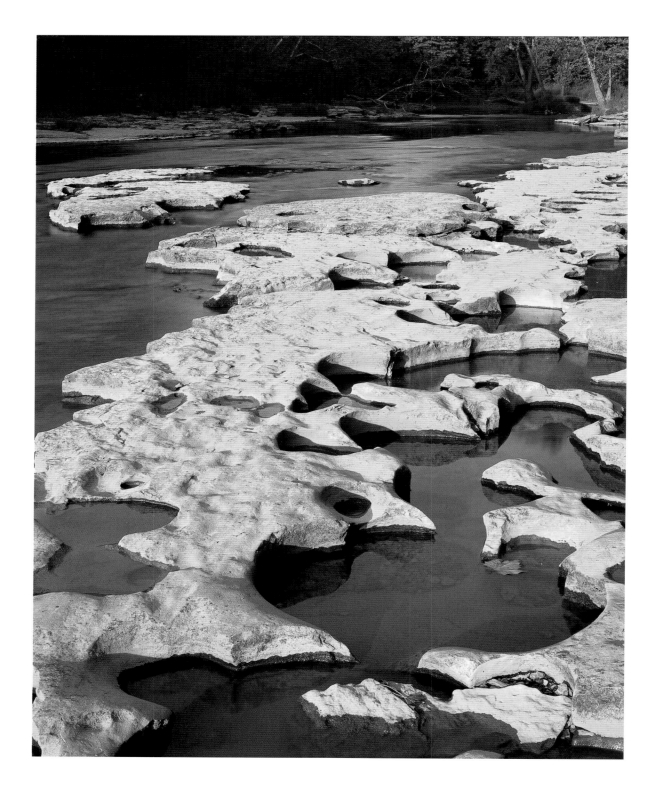

Late afternoon light illuminates
some of Mill Creek's bedrock [RL]

CATARACT FALLS STATE
RECREATION AREA

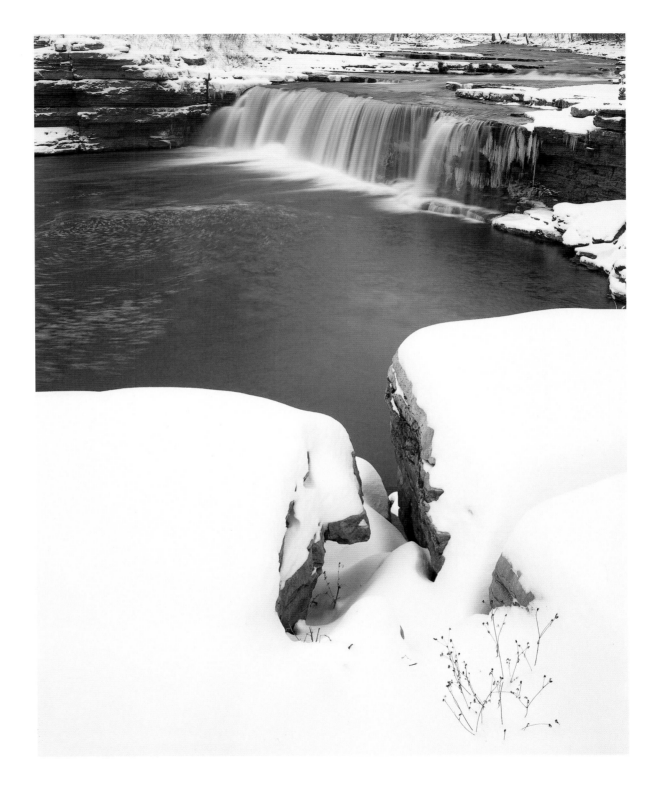

A wintry view of
Lower Cataract Falls [RL]

CATARACT FALLS STATE
RECREATION AREA

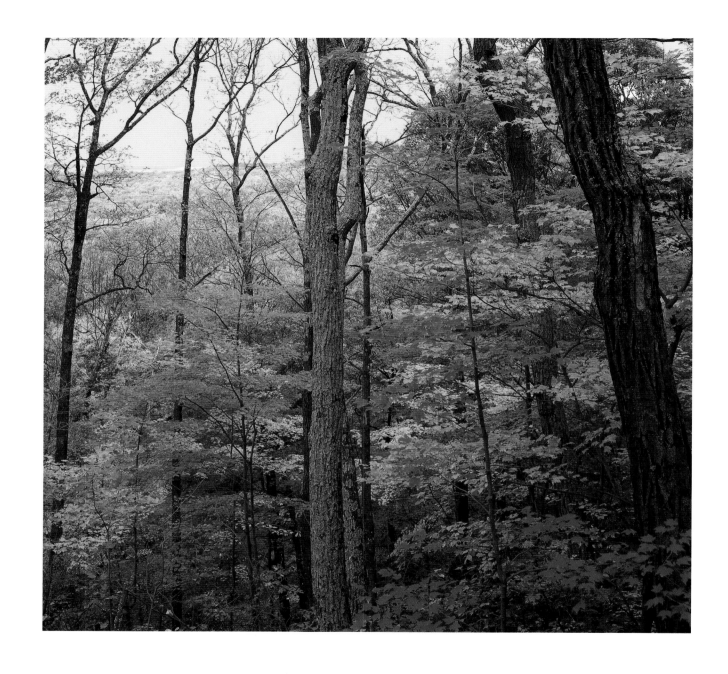

Fall colors frame a view across the hills [CJ]

JACKSON-WASHINGTON STATE FOREST

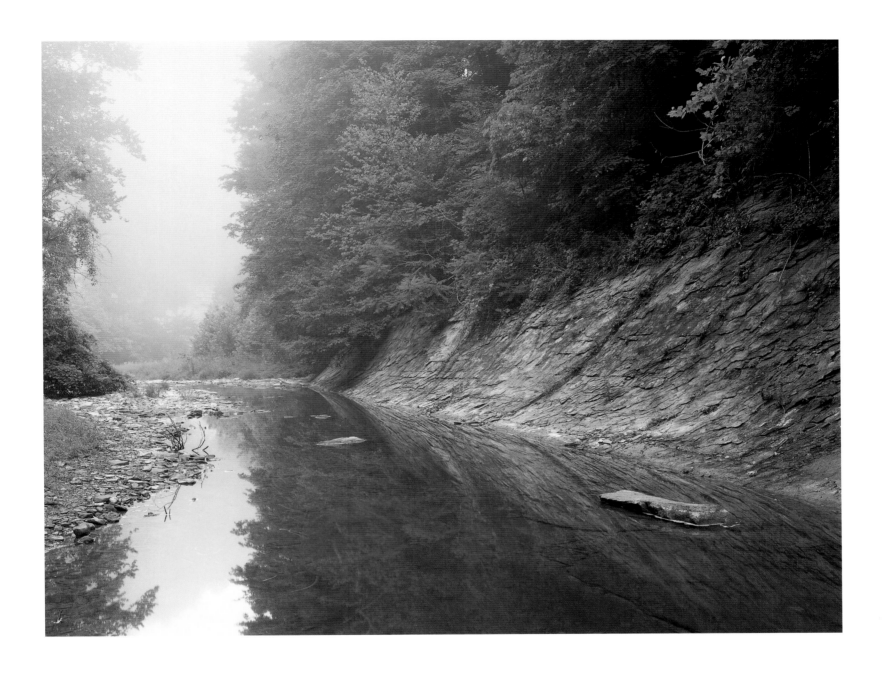

Foggy reflections along Indian Creek [RL]

PINE HILLS NATURE PRESERVE

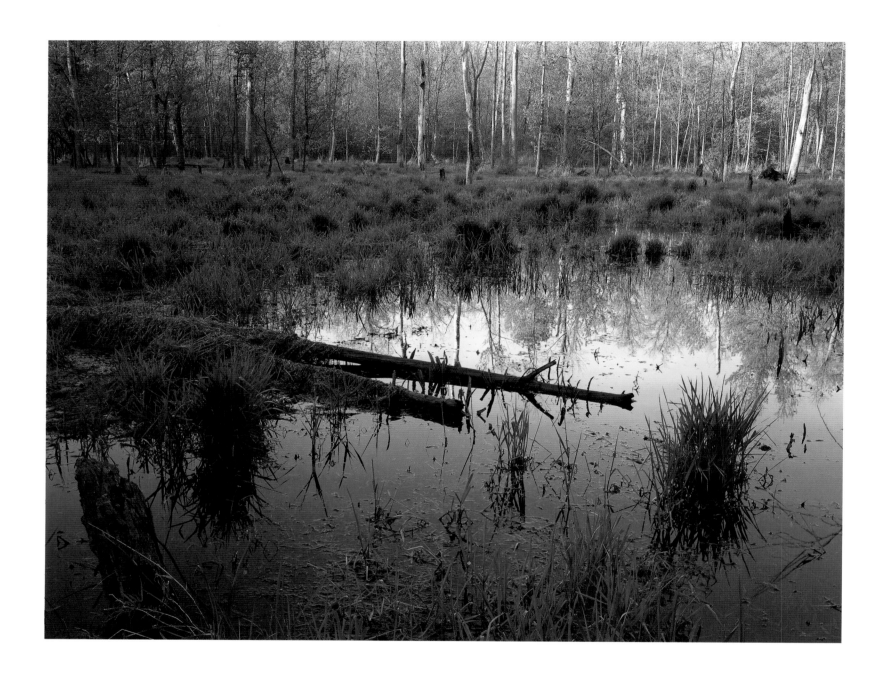

The sun's morning light reflects down onto the water of a woodland swamp [RL]

Vandolah Nature Preserve

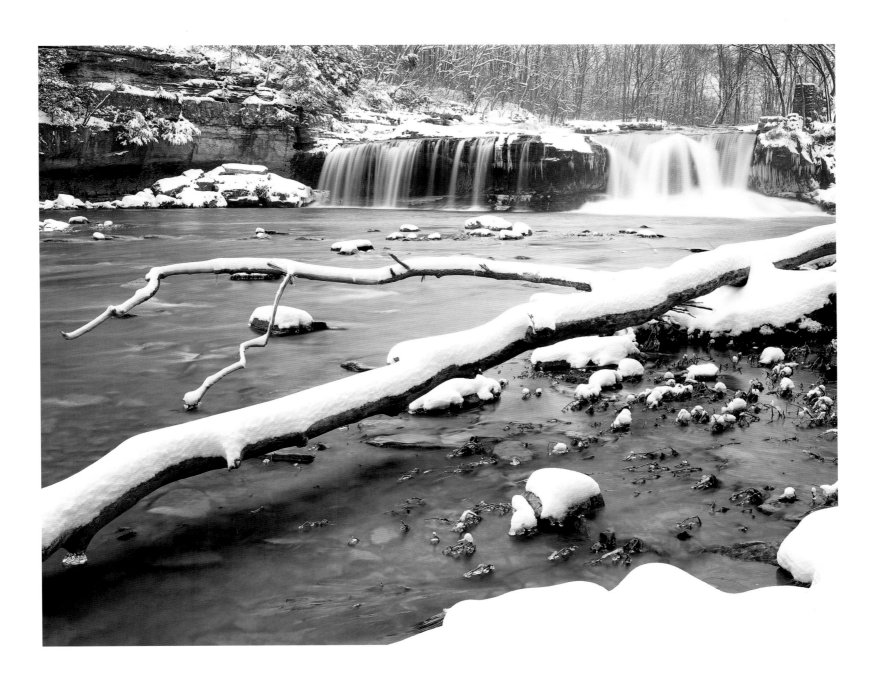

A fresh coat of snow dresses Upper Cataract Falls in Owen County [RL]

CATARACT FALLS STATE RECREATION AREA

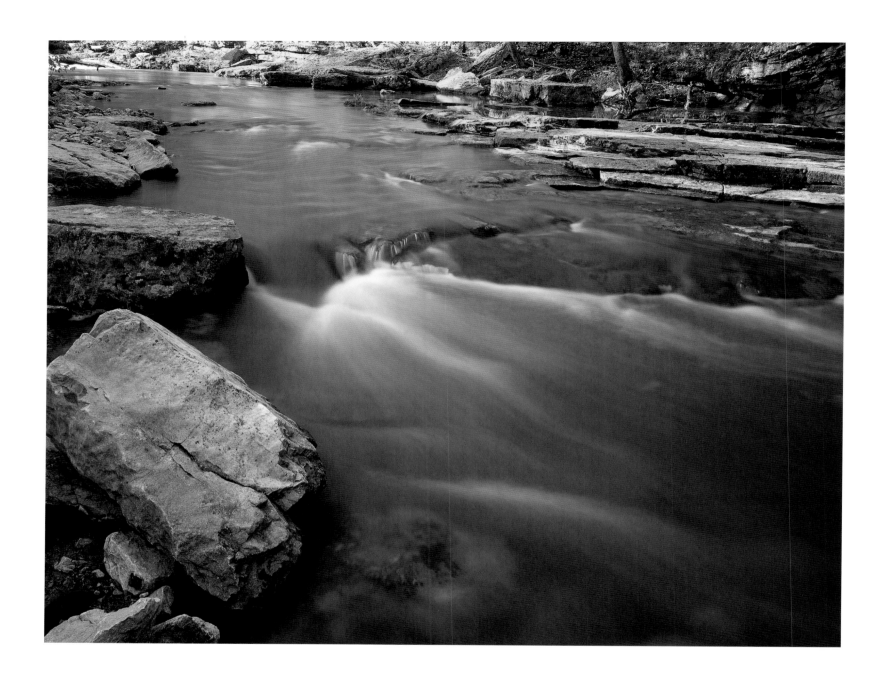

Morning light paints McCormick's Creek with shimmering color [RL]

McCormick's Creek State Park

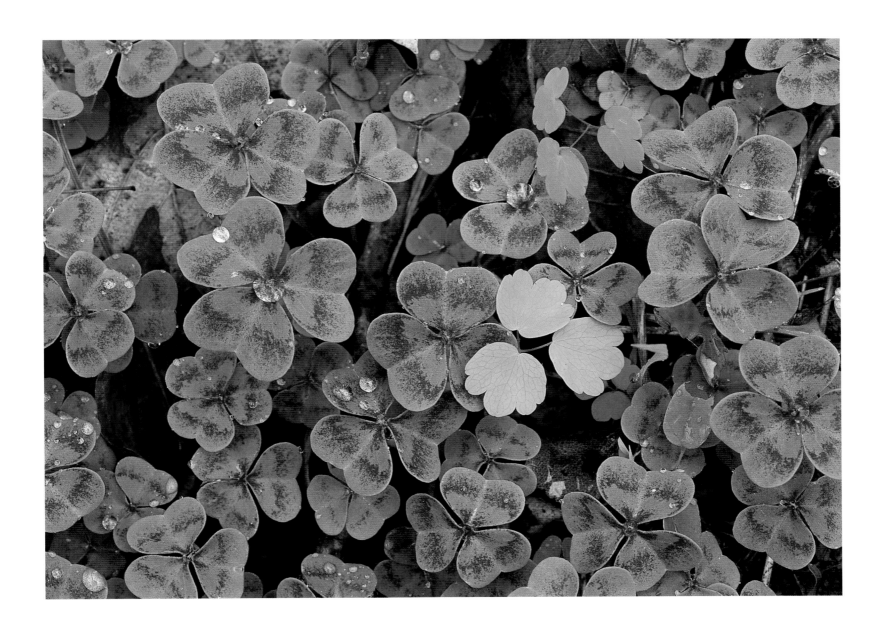

Pattern of violet wood sorrel leaves and raindrops [CJ]

SPRING MILL STATE PARK

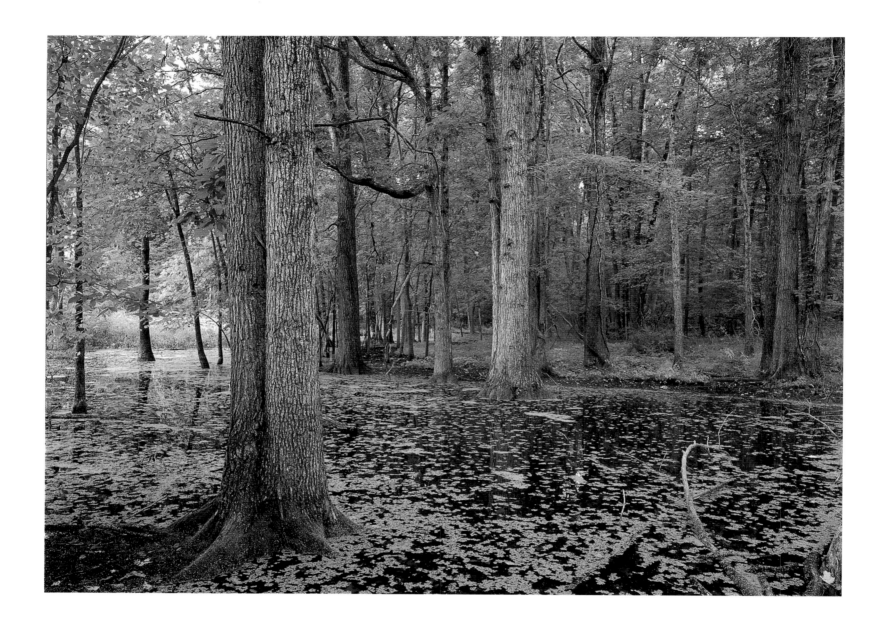

Wooded wetlands and duckweed [CJ]

POKAGON STATE PARK

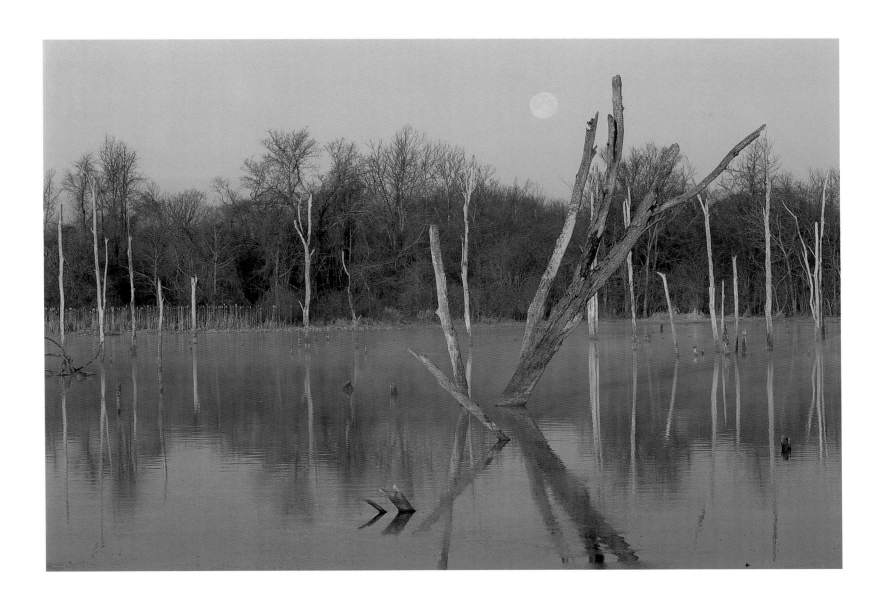

Warm morning light over Pisgah Lake [CJ]

ATTERBURY FISH & WILDLIFE AREA

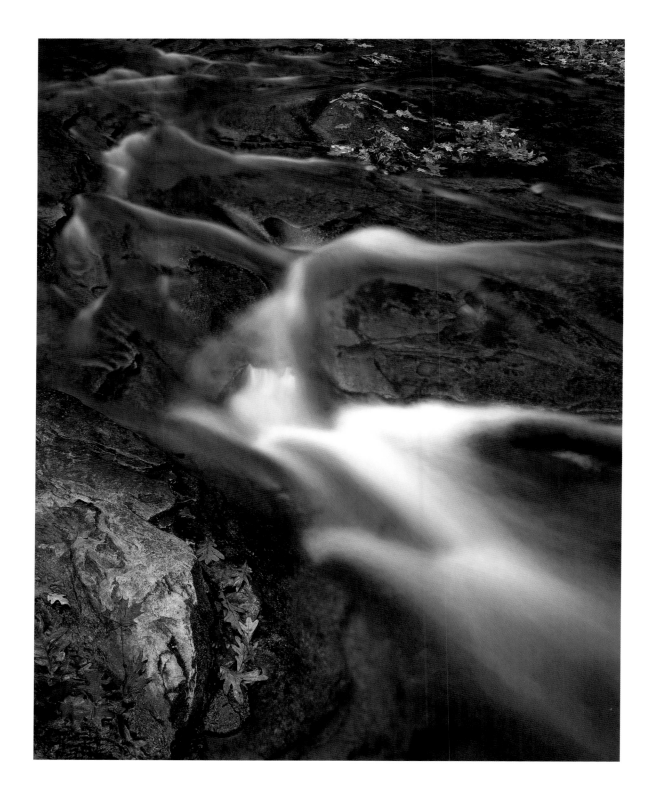

Swirling waters of Fall Creek [CJ]

FALL CREEK GORGE
NATURE PRESERVE

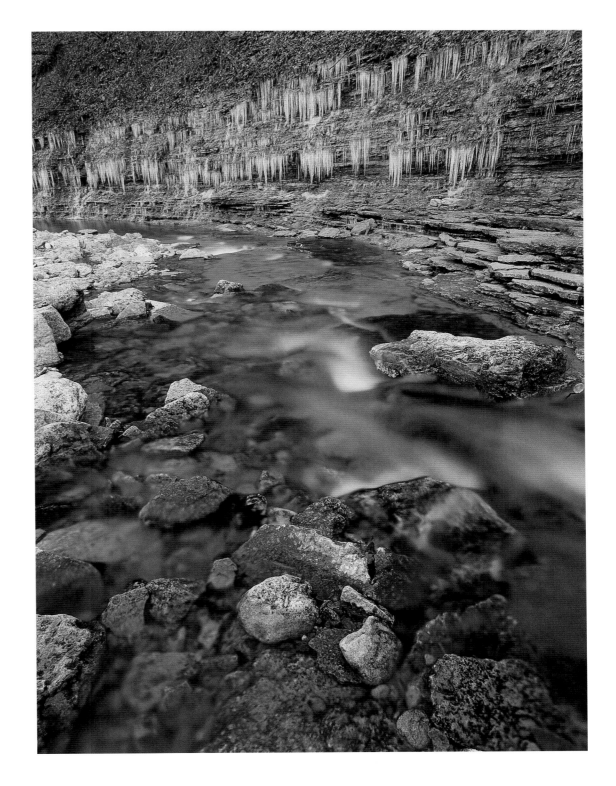

An icy view down Clifty Creek [CJ]

CLIFTY FALLS STATE PARK

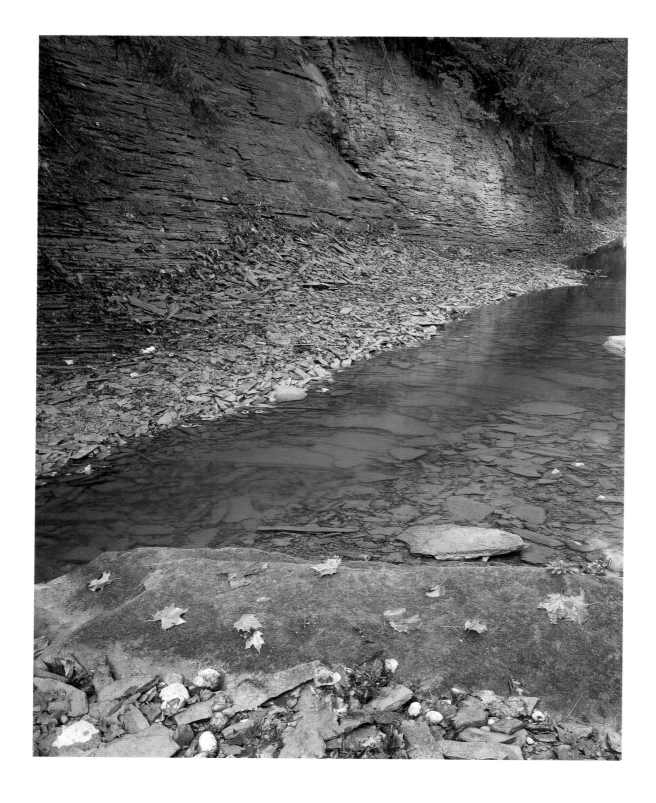

*Broken shards of shale
pile up along the bank of
Guthrie Creek* [RL]

HEMLOCK BLUFF
NATURE PRESERVE

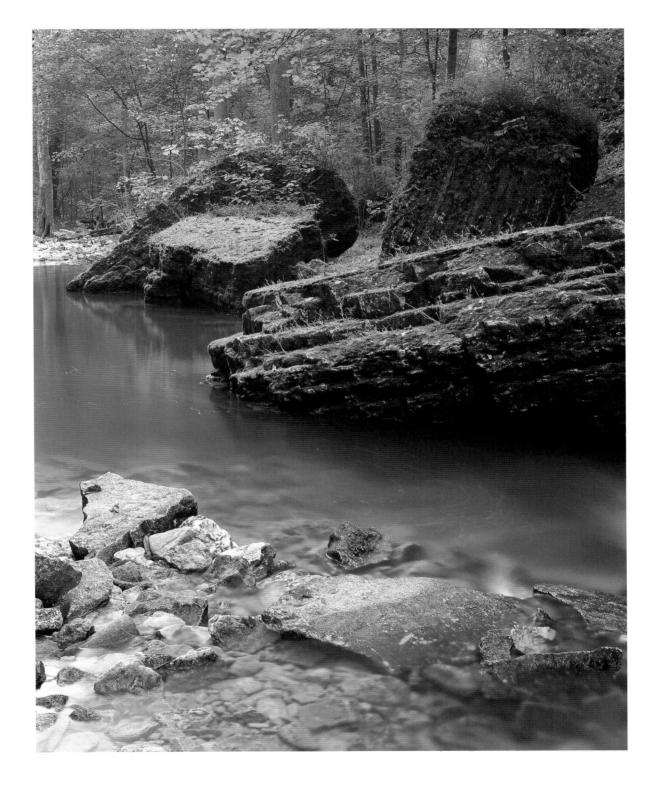

Limestone monoliths stand guard over one of Big Clifty Creek's quiet pools [RL]

CLIFTY FALLS STATE PARK

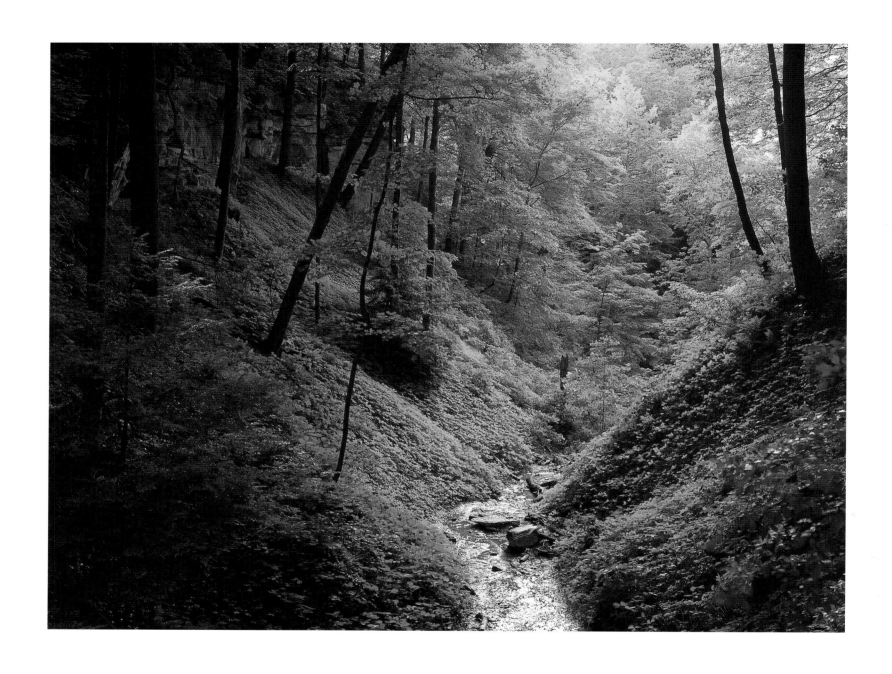

The wooded valley below Maidenhair Falls [CJ]

SHADES STATE PARK

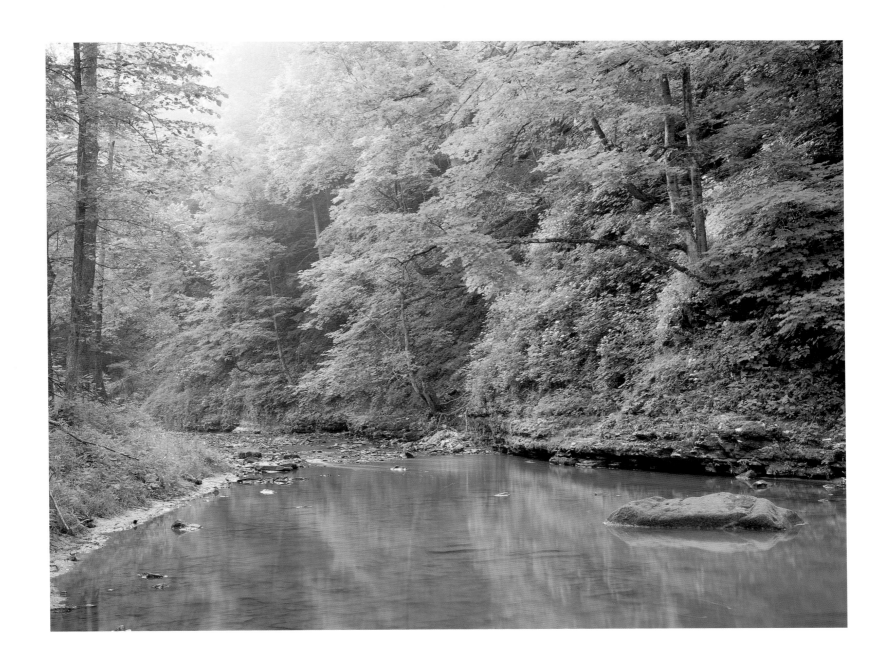

Lush vegetation hides the rocky slopes along Raccoon Creek [RL]

GREEN'S BLUFF NATURE PRESERVE

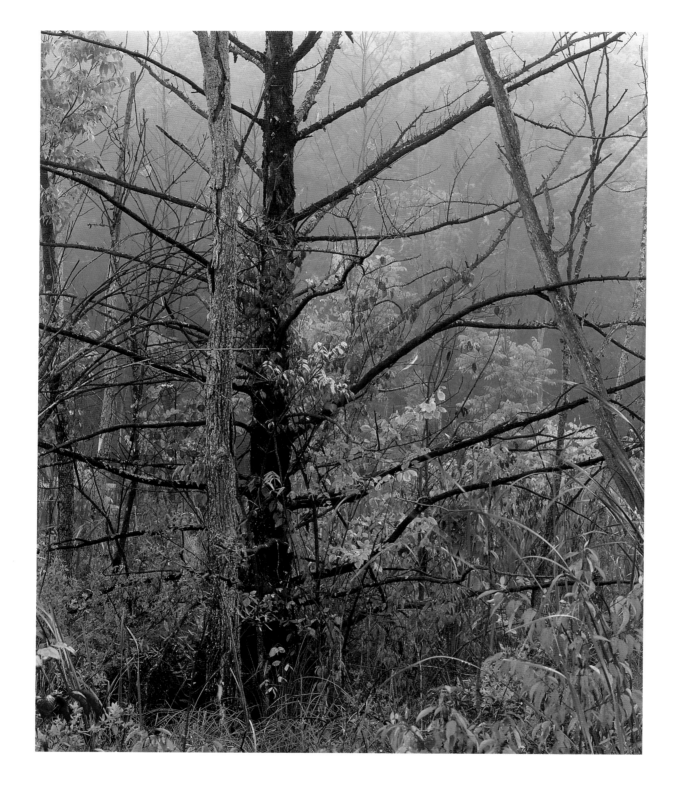

Bare trees in foggy wetlands [CJ]

POKAGON STATE PARK

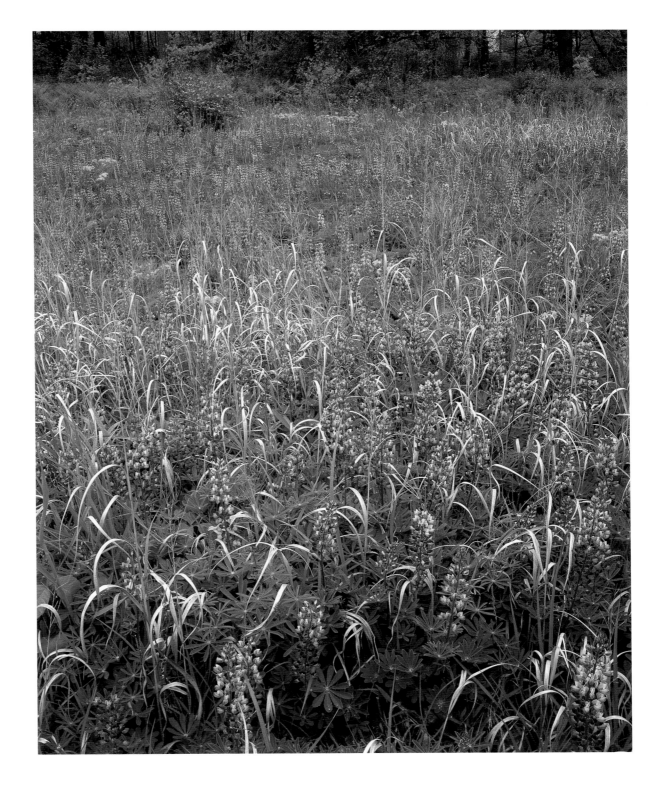

In late May, lupines dominate the inland area of West Beach [RL]

INDIANA DUNES
NATIONAL LAKESHORE

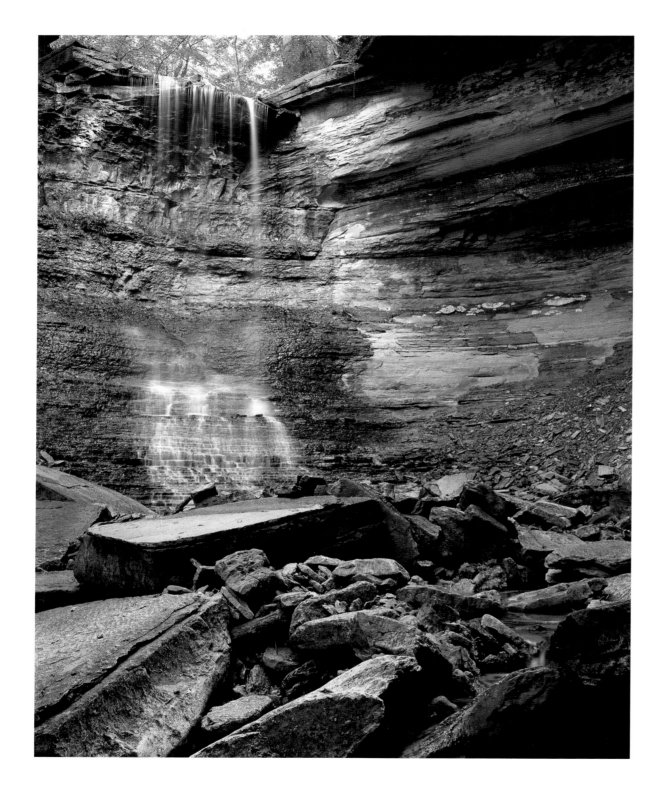

*Little Clifty Falls empties into one
of the park's many canyons* [RL]

Clifty Falls State Park

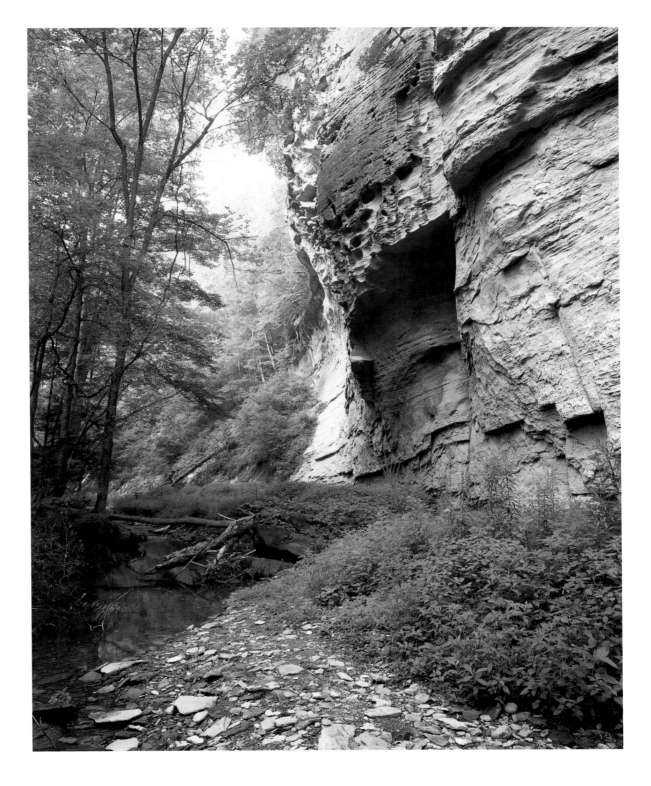

Honeycomb Rock towers over Indian Creek [RL]

PINE HILLS NATURE PRESERVE

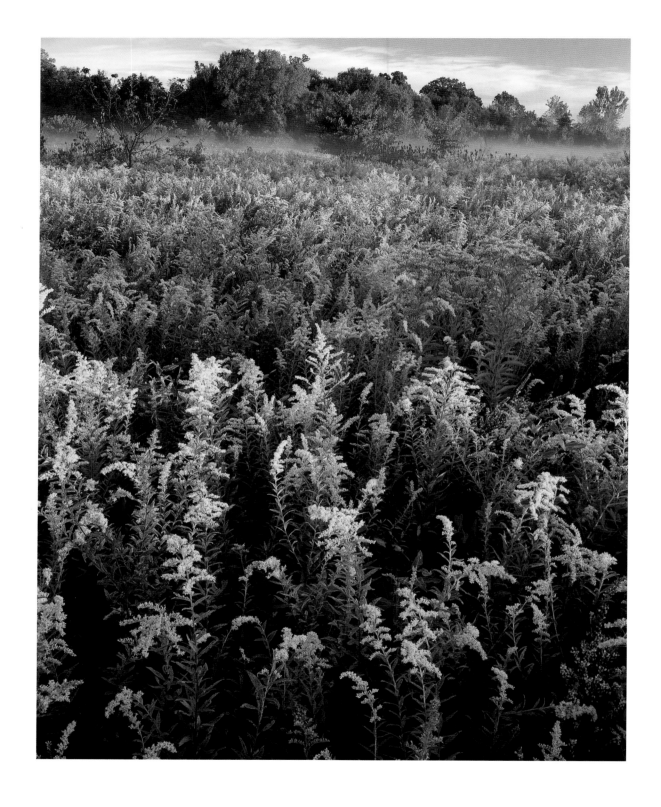

Goldenrod is accented by early morning's light and fog [RL]

HAMILTON COUNTY

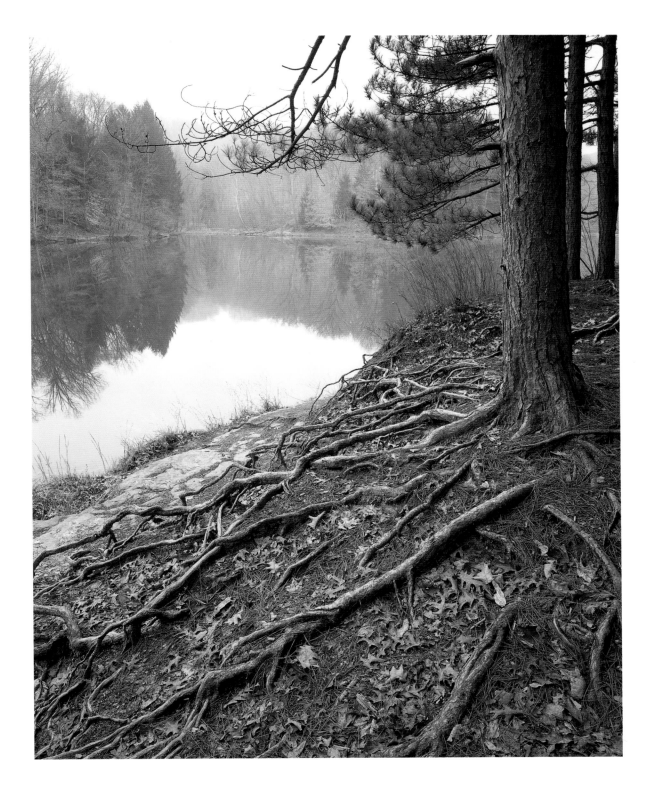

Pine trees maintain their grip along the shore of Strahl Lake [RL]

BROWN COUNTY STATE PARK

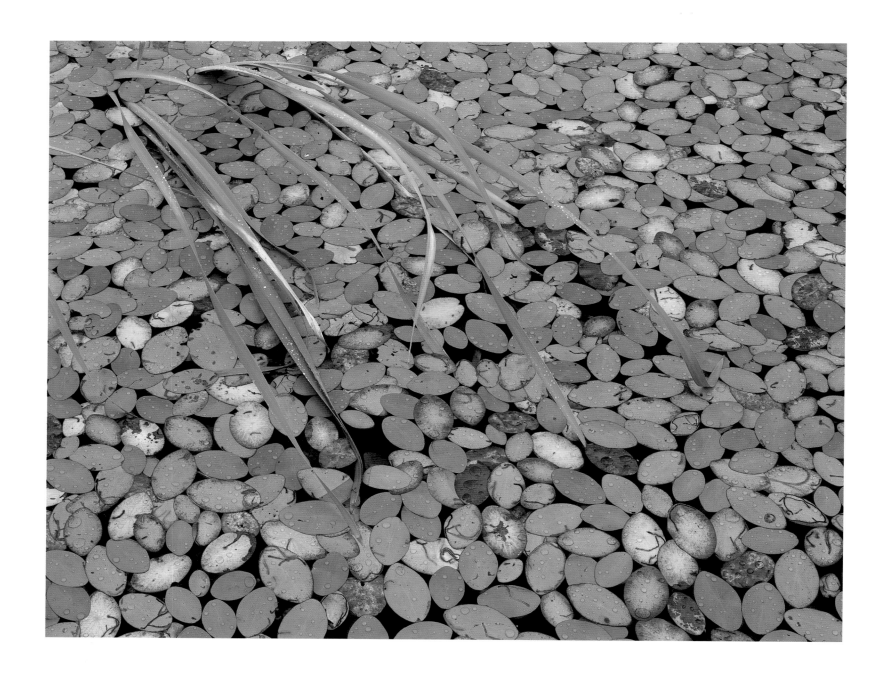

Cattails and water shield form a complex pattern in Schlamm Lake [CJ]

CLARK STATE FOREST

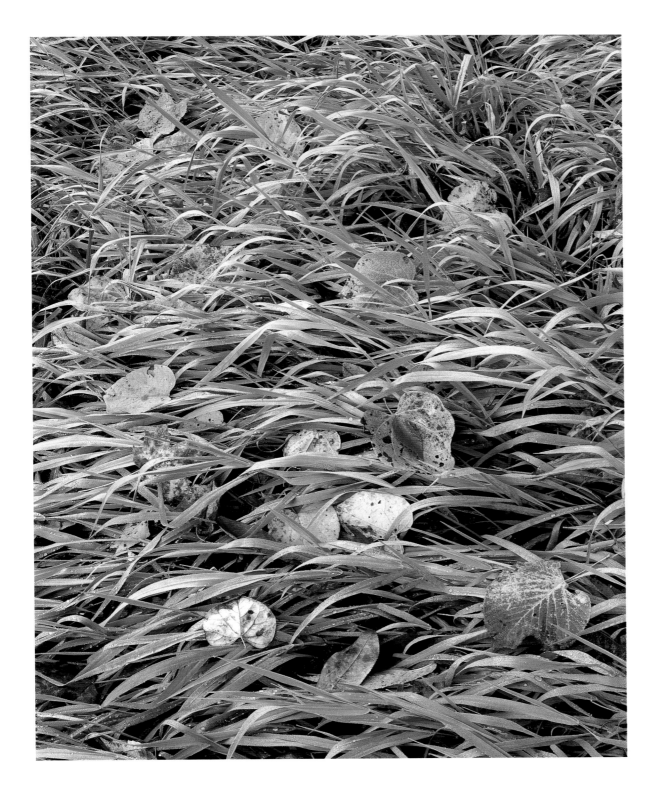

*Fallen leaves mingle with
dew-drenched grass along
Sugar Creek* [RL]

TURKEY RUN STATE PARK

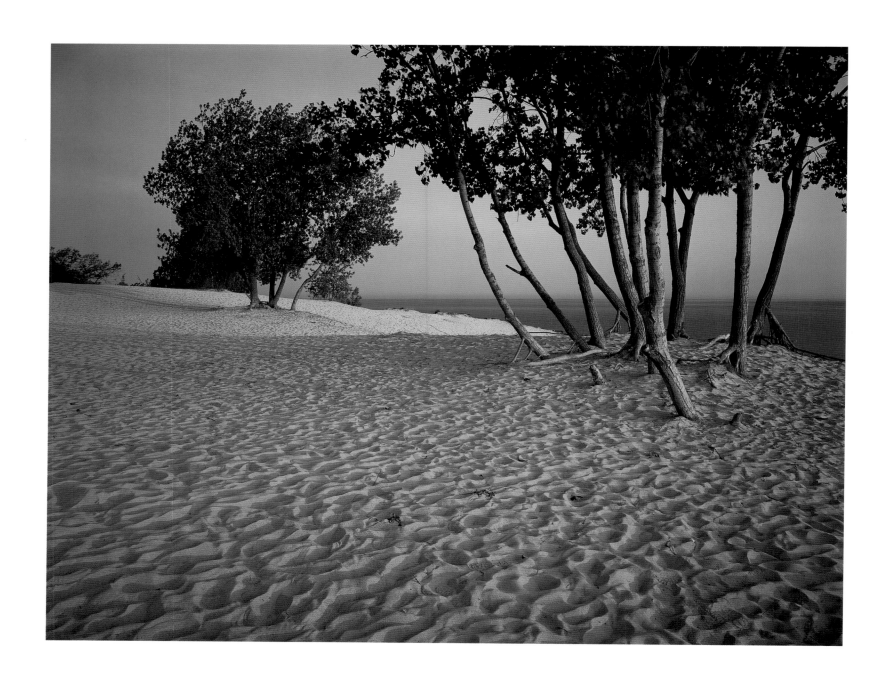

First light brings a warm glow to cottonwoods on top of Mt. Baldy [RL]

INDIANA DUNES NATIONAL LAKESHORE

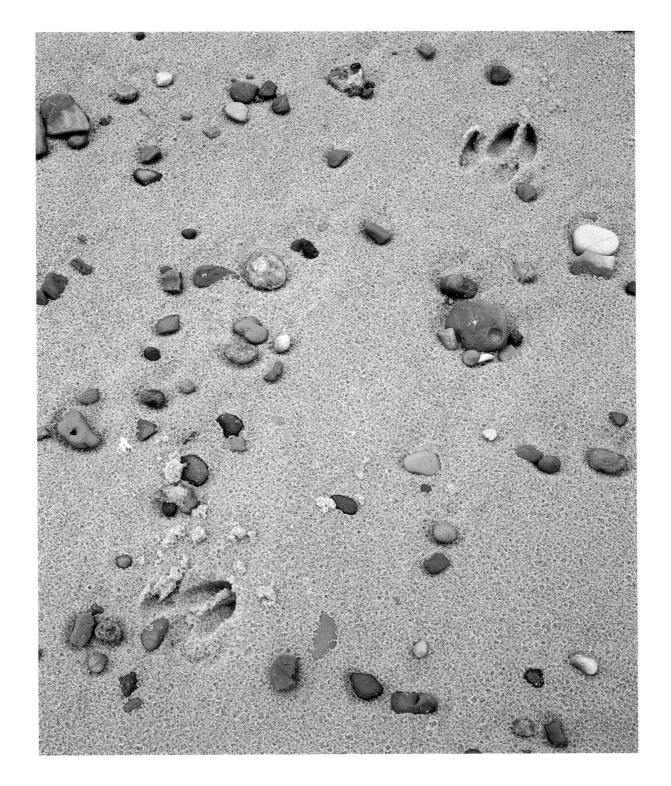

Deer tracks and beach stones [RL]

INDIANA DUNES
NATIONAL LAKESHORE

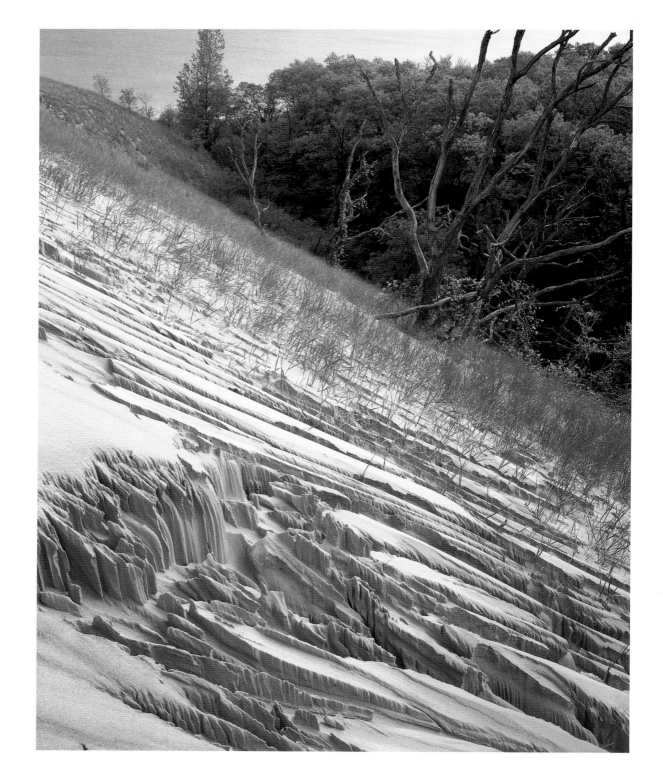

Constantly moving sand creates abstract patterns on Mt. Baldy [RL]

INDIANA DUNES
NATIONAL LAKESHORE

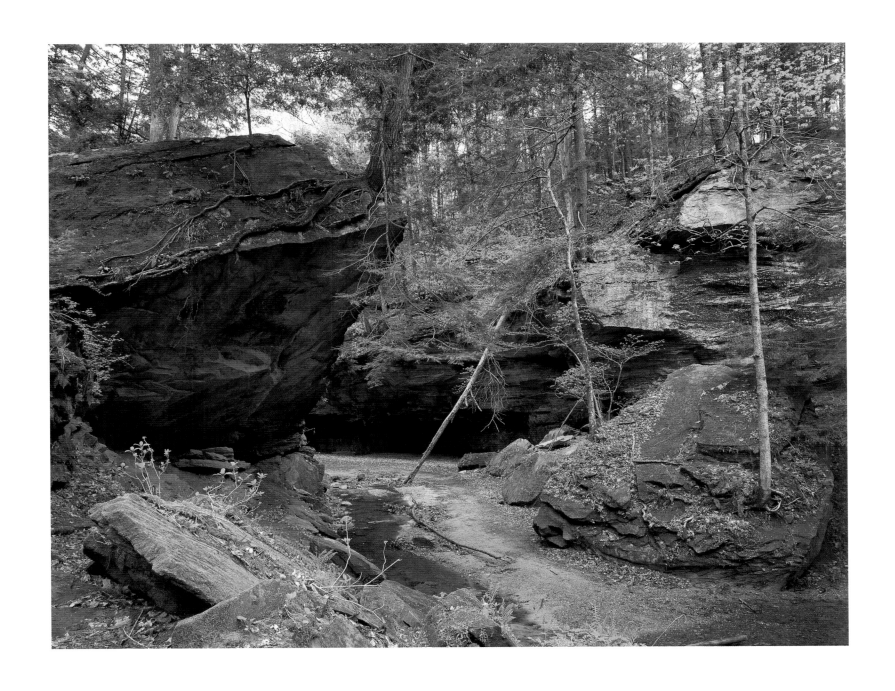

The rugged beauty that is typical of Rocky Hollow–Falls Canyon Nature Preserve [RL]

TURKEY RUN STATE PARK

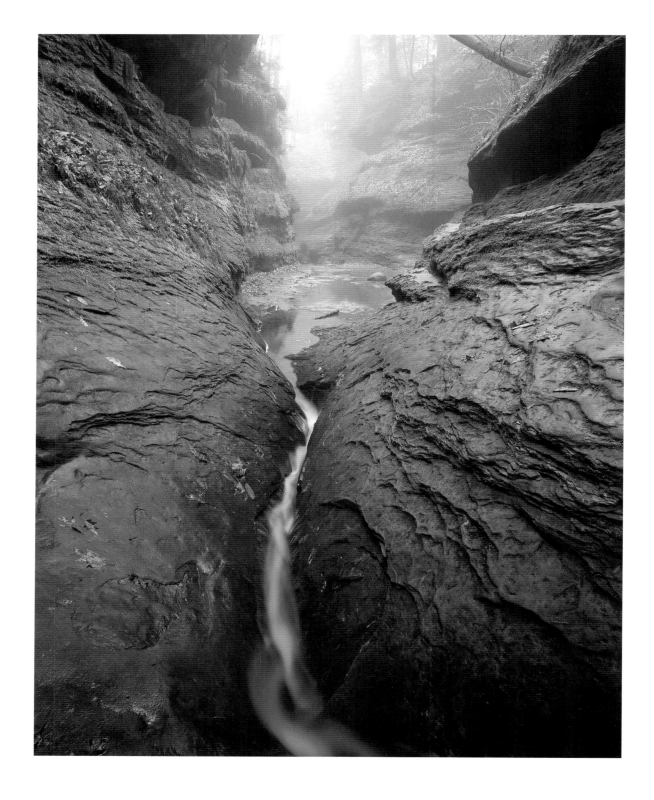

A foggy morning in the canyon [CJ]

TURKEY RUN STATE PARK

A mosaic of rock, root, moss, and lichen [CJ]

HOOSIER NATIONAL FOREST

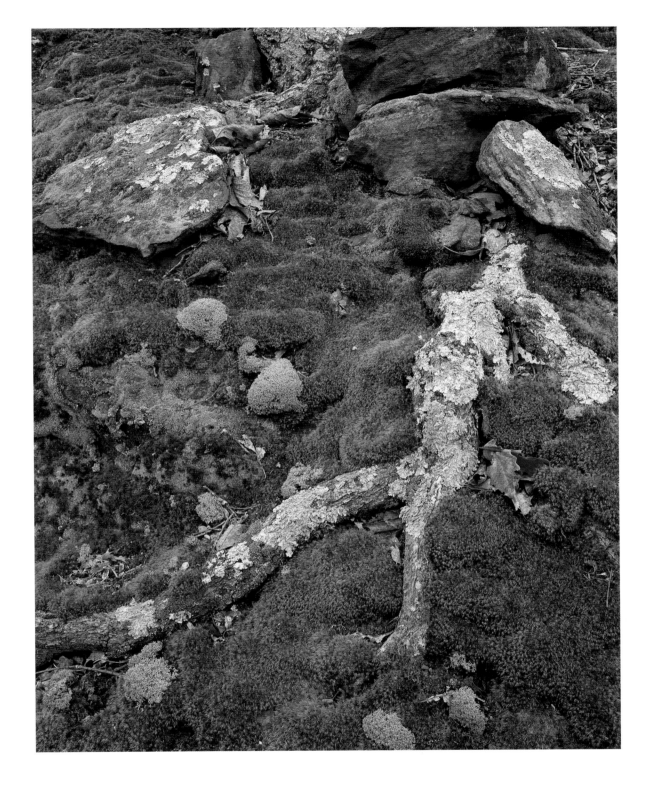

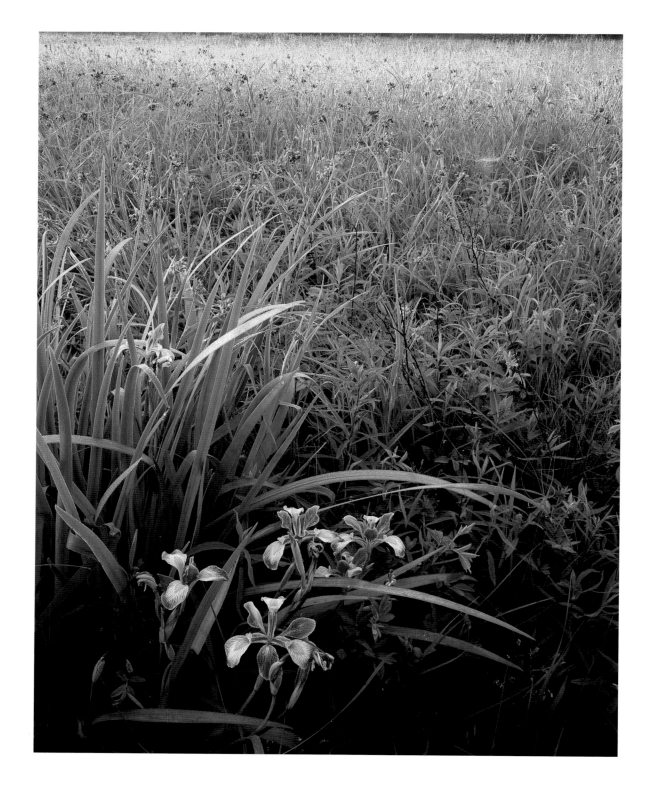

Blue flag and spiderwort await
the sun's morning light [RL]

Spinn Prairie
Nature Preserve

138

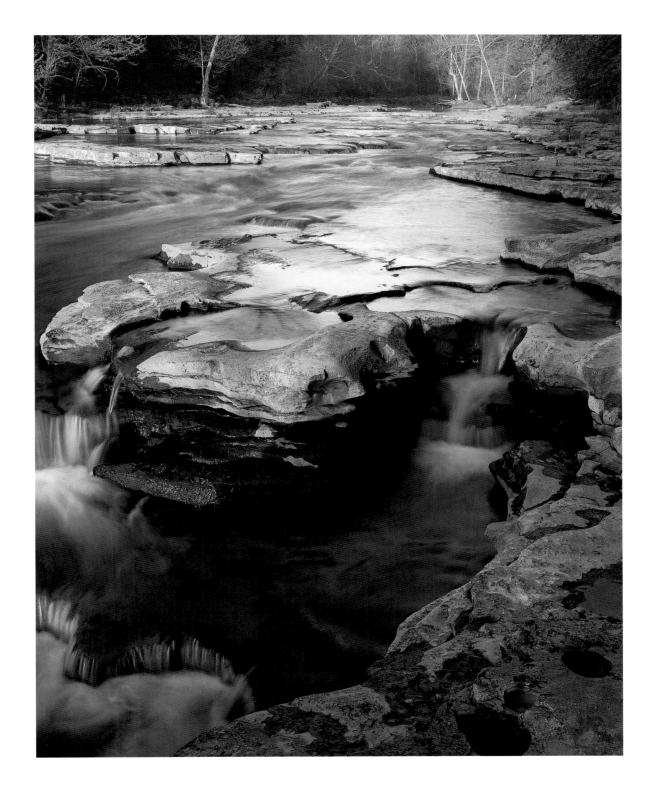

Late day light highlights the rocky features along Mill Creek [RL]

CATARACT FALLS STATE
RECREATION AREA

Bare trees silhouetted in heavy fog [CJ]

SUMMIT LAKE STATE PARK

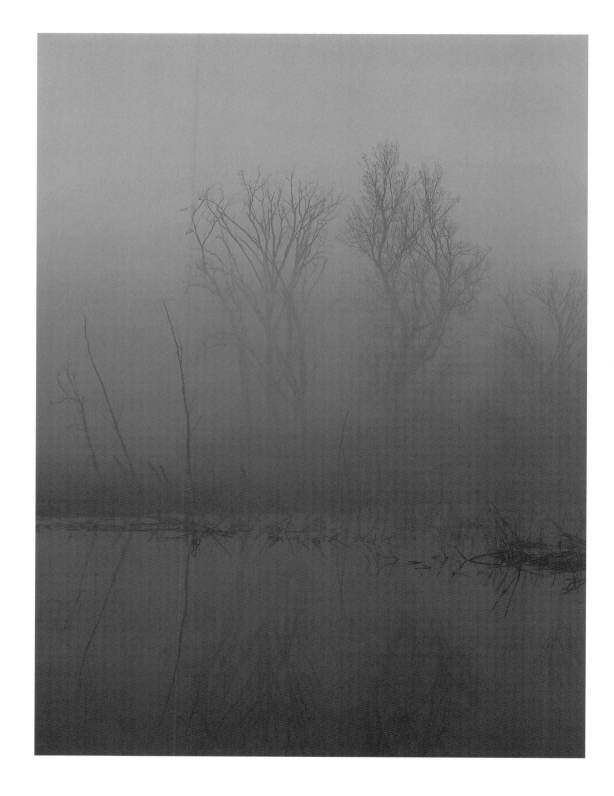

Technical Details

All of the photographs in this book were taken using either medium or large format camera equipment. The Pentax 645N medium format camera system was used for all medium format images, with Pentax lenses ranging in focal length from 35mm wide angle to 200mm telephoto. Large format cameras included an Arca-Swiss monorail field camera, a Walker Titan field camera, and a Zone VI field camera, all in 4 x 5 inch format. The large format lenses used were made by all the major manufacturers (Fuji, Nikon, Rodenstock, and Schneider) and covered focal lengths from 80mm wide angle to 305mm telephoto. Most of the panoramic photographs in the portfolio were taken using a Horseman 612 roll film back on the large format cameras.

Fujichrome Velvia (50 and 100F) and Kodak E100VS were the main film types used to capture these images. Fujichrome Provia and Astia were also used in certain situations.

The most commonly used filter was a polarizing filter to eliminate glare and help saturate colors. Color-correcting filters were sometimes used to counteract the effects of reflected sky or reciprocity failure–related color shifts due to long exposures. Graduated neutral density filters were occasionally used to minimize the contrast range of a scene.

All photographs were taken with the camera mounted on a sturdy tripod (Gitzo and Ries brands were used). Lens aperture/shutter speed combinations were usually chosen to maximize depth of field in a given situation. Shutter speeds ranged from $1/4$ second to as long as 2 minutes. Lens apertures ranged from f11 to f32 for medium format images, and from f16 to f64 for large format images.

We have chosen not to provide detailed lens/aperture/shutter speed data for a few reasons. The choice of lens in a particular situation is governed by how the photographer

chooses to record a scene, and knowledge of the lens used is not (in our opinion) very informative when the observer is not at the same location in the field to see how that lens determines the framing of the image. Similarly, the combination of aperture and shutter speed chosen to provide a correct exposure with adequate depth of field is so dependent on ambient light and wind conditions that this information is also not helpful without detailed descriptions of the weather and lighting conditions—information beyond the scope of this book. Our primary goal is to share with the reader our love of the diverse natural landscapes of Indiana, not to provide a technical treatise on landscape photography. However, because of the inherent interest that photographers have in equipment (ourselves included), we have provided the information above in hopes that it will be at least partially informative.

List of Resources

The areas photographed for this book are administered by a variety of organizations dedicated to the preservation and protection of the remaining natural landscapes of Indiana. Without their tireless efforts to identify, acquire, and protect the sites that we visited and photographed, this book and the opportunities for recreation, relaxation, and solitude that these sites provide would not have been possible. We encourage you to visit the parks, nature preserves, forests, and recreation areas of the state to appreciate these natural treasures firsthand. More important, we hope that you will support these organizations with your time and/or money so that the fine work they do can continue.

The Nature Conservancy
Indiana Field Office
1505 North Delaware Street, Suite 200
Indianapolis, IN 46202
http://nature.org/indiana

Indiana Department of Natural Resources
402 West Washington Street
Indianapolis, IN 46204
http://www.in.gov/dnr/

Indiana Dunes National Lakeshore
1100 North Mineral Springs Road
Porter, IN 46304
http://www.nps.gov/indu/

Hoosier National Forest
811 Constitution Avenue
Bedford, IN 47421
http://www.fs.fed.us/r9/hoosier/

RON LEONETTI

has been photographing the natural world for more than twenty years. His photographs have appeared in various publications, including *Michigan Natural Resources; Wyoming Wildlife;* and *Nature Canada.* Over the last several years his focus has been capturing wild and scenic landscapes with a large format camera. His award-winning photography is widely exhibited and displayed in many private and public collections. Sharing his vision of nature and the preservation of wild places with the public has always been a driving force in his work.

CHRISTOPHER JORDAN

has been sharing his passion for the natural world through photography for six years. Born and raised in Indiana, he specializes in finding intimate and unexpected beauty in the natural landscapes of the Midwest, Southeast, and East. He works in medium and large formats. His work has been published in promotional materials for the Indianapolis Museum of Art, the Indiana Chapter of The Nature Conservancy, and the Brown County (Indiana) Board of Tourism. His images are showcased in public and private collections throughout the United States.

For more information about the photographers and their work, please contact
Ron Leonetti at rmlphotography@aol.com or Christopher Jordan at cjphotography@msn.com.

Book and Jacket Designer
Sharon L. Sklar

Copy Editor
Jane Lyle

Compositor
Sharon L. Sklar

Typefaces
Janson and Serlio

Book and Jacket Printer
Four Colour Imports